Lewis Rubenstein

A Hudson Valley Painter

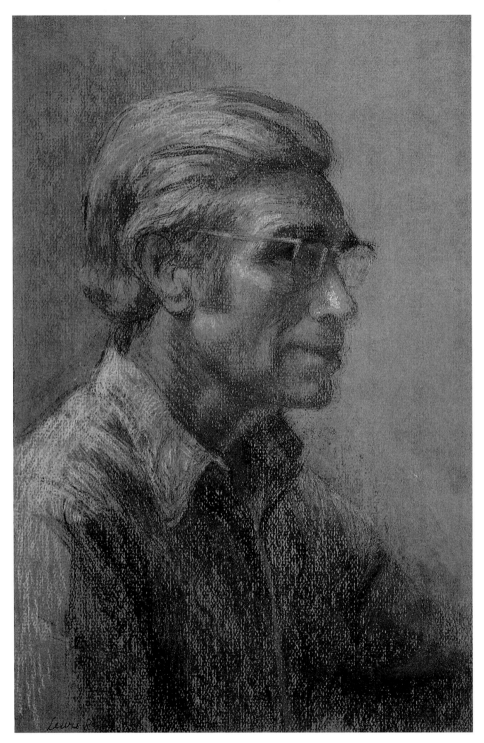

Self-Portrait, ca. 1991
Pastel on gray paper, 20 x 13 in.
Collection of the artist

Lewis Rubenstein

A Hudson Valley Painter

Foreword by
Nicolai Cikovsky, Jr.

Essays by
Ruth L. Middleton, Douglas Dreishpoon,
and Rebecca E. Lawton

Dutchess County Art Association
Poughkeepsie, New York

and

The Overlook Press
Woodstock, New York

Front cover: *Iona Island,* 1988
Back cover: *Mount Carmel,* 1978

This publication was supported in part by generous support from
the Richard A. Florsheim Art Fund
and from
the Lucy Maynard Salmon Fund, Vassar College

Designed by Abigail Sturges
Edited by Carol Scarvalone Kushner
Photographs by Mike Djirdjirian
Typography by Bauer Typography

Printed in Mexico

First published in 1993 by
Dutchess County Art Association
55 Noxon Street
Poughkeepsie, New York 12601
and
The Overlook Press
Lewis Hollow Road
Woodstock, New York 12498

Library of Congress Cataloging-in-Publication Data

Middleton, Ruth.
 Lewis Rubenstein : a Hudson Valley painter / foreword by Nicolai
Cikovsky, Jr. ; essays by Ruth L. Middleton, Douglas Dreishpoon,
and Rebecca E. Lawton.
 p. cm.
Includes bibliographical references.
 1. Rubenstein, Lewis W. (Lewis William), 1908- . 2. Artists-
United States-Biography. 3. Hudson River Valley (N.Y. and N.J.)
in art. I. Rubenstein, Lewis W. (Lewis William), 1908- .
II. Dreishpoon, Douglas. III. Lawton, Rebecca. IV. Title.

N6537.R77M54 1993
759.13—dc20

ISBN : 0-87951-515-5

93-19589
CIP

Contents

6 List of Plates

7 Foreword
 Nicolai Cikovsky, Jr.

9 **A Retrospective**

10 Time and the River
 Ruth L. Middleton

55 **Time Paintings**

56 Moving in Time:
 The Time Paintings of Lewis Rubenstein
 Douglas Dreishpoon

72 Chronological Biography
 Rebecca E. Lawton

80 Acknowledgments

List of Plates

Fig. 1 *Grandmother*

Fig. 2 *Winter Lake*

Fig. 3 *Every Valley*

Fig. 4 *Main Street* (detail)

Fig. 5 *Teemer's Back* (also known as *Steelworker*)

Fig. 6 *Jefferson Street*

Fig. 7 *Picnic in Mexico*

Fig. 8 *Good Friday*

Fig. 9 *Fishermen*

Fig. 10 *Gleaners I*

Fig. 11 *Noh Dance*

Fig. 12 *Piazza Navona*

Fig. 13 *Spanish Steps*

Fig. 14 *Currant Pickers*

Fig. 15 *Urban Renewal*

Fig. 16 *Chassidic Wedding*

Fig. 17 *Praise Him with Dance*

Fig. 18 *Thou Renewest the Face of the Earth*

Fig. 19 *Schoodic Point*

Fig. 20 *Reflections II*

Fig. 21 *Oregon Coast*

Fig. 22 *Mount Carmel*

Fig. 23 *Catskill Twilight*

Fig. 24 *Let the Waters Teem*

Fig. 25 *Who Stretchest Out the Heavens Like a Curtain*

Fig. 26 *There Went Up a Mist*

Fig. 27 *Gleaners*

Fig. 28 *Sea Gleaners*

Fig. 29 *Mill Street*

Fig. 30 *Ashokan*

Fig. 31 *Up River*

Fig. 32 *Mid-Hudson Bridge*

Fig. 33 *Iona Island*

Fig. 34 *Coming Storm*

Fig. 35 *Bear Mountain*

Fig. 36 *Mid-Hudson*

Fig. 37 *Quarry II*

Fig. 38 *Autumn Stream*

Fig. 39 *Winter Walk* (detail)

Fig. 40 *Winter Walk* (detail)

Fig. 41 *Winter Walk* (detail)

Fig. 42 *Main Street* (detail)

Fig. 43 *Main Street* (detail)

Fig. 44 *Dunes*

Fig. 45 *Dunes* (detail)

Fig. 46 *Dunes* (detail)

Fig. 47 *Nazaré* (detail)

Fig. 48 *Nazaré* (detail)

Fig. 49 *Nazaré* (detail)

Fig. 50 *Psalm 104* (detail)

Fig. 51 *Psalm 104* (detail)

Fig. 52 *Water* (detail)

Fig. 53 *Water* (detail)

Foreword

Nicolai Cikovsky, Jr.
Curator of American Art
National Gallery of Art
Washington, D.C.

It was my good fortune to know Lewis Rubenstein about twenty years ago, in the early 1970s when, for just a few of the many years he taught there, we were colleagues in the art department of Vassar College. I was the director of the art gallery. One of my last acts and greatest pleasures as director was to help in a small way with the organization and presentation of the retrospective exhibition of Lewis' work that was held at the Vassar College Art Gallery in the spring of 1974. I am not being excessively modest. He may be kind enough to say that I played an important role, but he really did most of the work. The part I remember with greatest fondness is working with Lewis on the introduction to the catalogue of the exhibition. I was supposed to write it, and to help me Lewis supplied a tape recording of his own observations on his work. I saw immediately that Lewis was his own best critic and commentator, and he consented, after a little arm twisting, to let me simply transcribe his own words as the introduction. It was vastly better than anything I could have written. It is rare that artists speak about their work, and rarer still that they are able to speak about it with such clarity, charm, and candor as Lewis did. I am grateful to him for consenting to let me convince him to leave that important legacy.

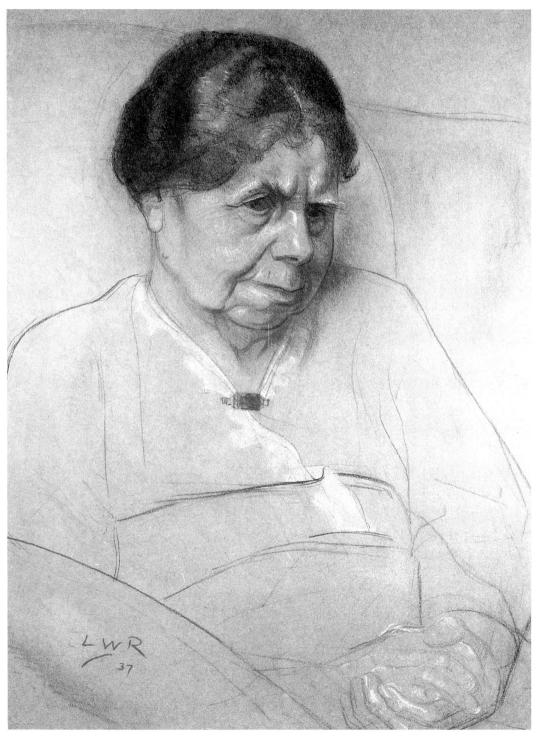

Fig. 1
Grandmother, 1937
sepia, black and white conté crayon on
green paper, 25 x 19 in.
Collection of the artist

A Retrospective

Time and the River

Ruth L. Middleton

The studio is as I remember. Autumn light pouring through the windows evokes memories of tutorial appointments with C. K. Chatterton, head of the studio art department during my years at Vassar. But two large paintings on the wall opposite the windows, *The Gleaners* and *Oregon Coast* and the empty frame for a Time Painting on the easel behind the table where I am seated indicate the presence of his successor, Lewis Rubenstein. He has changed very little, also. The bright red hair is now white, but the voice, the gentle manner, the dry humor, are unaltered. I remind him of another fall afternoon in 1941 when he announced to the water-color class, gathered to paint out of doors near the Circle, that he would be leaving shortly to do camouflage work for the Armed Forces. There had abeen a brief period of stunned silence, followed by a burst of questioning:

"But, Mr. Rubenstein, you *will* return after your tour of duty, won't you?"

"Of course I will!"

And of course he did—moving on to become head of studio art in his turn. But it was too late for me to benefit. I had long since graduated and, in spite of continuing interruptions, was becoming a professional artist myself.

Now, as I turn the pages of the folio of Rubenstein's work chosen for a book devoted to the distinguished career that followed, my mind is flooded with memories and unanswered questions.

RM: Looking over these reproductions of work in fresco, water-color, and *sumi* ink, I notice that you have deliberately chosen the most demanding technique—that of water-based media. Why is that?

LR: If you want a personal reflection on that, I think it is because I have a very indecisive nature and these techniques force me to be decisive. Water-based media are essentially performances in time. And, with one cake of fine Chinese ink, one can really hold the world in one's hand.

Those expressions—"performances in time" and "hold the world in one's hand"—have provided the context for my consideration of the extensive documents, slides, reprints, and interviews that made it possible to piece together activities covering a span of fifty years.

During lengthy conversations in preparation for this work, Lewis and I have devoted much of our discussion to the place of the arts in our contemporary culture, so shaped by increasingly sophisticated technologies. What role do they play, if any, in the educational process? What do artists *do*, and where do we fit in the hurly-burly of cooks and contractors, of members of the House of Representatives and bank robbers and rock stars? How do we justify our activity in the face of the global crisis now confronting our civilization? Does it serve any definable purpose? Is there a valid reason to encourage today's youth to follow the same course?

When, in 1897, Joseph Conrad defined art as "a single-minded attempt to render the highest kind of justice to the visible universe" he knew what he was doing.[1] In 1992 things are less certain, the points of connection more obscure between the activities of those who profess to practice "art" and the rest of the population. In confronting these questions, I have received assistance from an unexpected quarter. The late Gregory Bateson, explorer in the realms of anthropology, psychology, and biology, and certainly one of the most original thinkers of our time, coined a phrase: "the patterns which connect."[2]

I re-discovered Bateson recently on a bottom shelf in the recesses of a Martha's Vineyard book store. *Mind and Nature—A Necessary Unity* was waiting just for me. I picked up the volume and began to leaf through it.

GB: Having trouble with the Rubenstein project, are you?

RM: Well, yes, as a matter of fact. I keep bumping into unanswerable questions, such as—

GB: —relevance?

RM: You've got it.

GB: Well, if it's all right with you, I'll come along for the ride.

RM: As I remember you're the one who pointed out that "the map isn't the territory." What I really need is a navigator to help me cross a territory full of dangers and pitfalls.

GB: Dangers and pitfalls?

RM: Yes—all the presumptions of "art history." The tyranny of linear chronology, cause-and-effect, justification—the many fragile links in the chain of evolving "human perfectability."

GB: Well, as you know, I devoted a life-time to struggling with problems of evolution without finding the answers that satisfied me. But never mind. I'm always up for a challenge. Let's have a go at it!

And so Bateson and I return to my little porch overlooking the ocean and the distant dunes of Cape Cod where Lewis Rubenstein had found so much inspiration to examine *Mind and Nature*.

In devoting a lifetime to exploring the physical "stuff" of the universe Bateson identified innumerable connections linking inert matter, living species, and human mental activity in unexpected ways. He saw the universe as an evolving tapestry of associations, a flow of information that is repetitive and rhythmical—a "dance of interacting parts." An examination of Rubenstein's paintings in this context reveals three significant patterns that reinforce the formal structure of his work. During the course of our interviews he identified the three metaphors that imbue his work with meaning, the important connections with his own life experience, from the early frescoes to the most recent watercolors of the Hudson River landscape—Water, Time, and the Sacred Image.

Patterns as Metaphor: Water

The day is brisk and copper-gold hues animate the hills overlooking the Hudson. Seated on a stool, an absorbed Rubenstein is hunched over a sheet of water-color paper. As he begins to lay out the familiar scene of the river winding through its valley below, he comments to the journalist, who has come for a televised interview, that this is one of his favorite spots—a hillside where he often comes to paint. He seems never to tire of the River. The work begins with a rectangle of white paper—empty of all form, untouched by any brush. Then a rivulet of expanding water spreads across its surface. Before colors delineate form, create space, produce movement, there is clear, pure water. A small river, connected in meaning with all the waters of history is linked in form and substance with the river that flows within, animating the eye, the hand, and the brain of the artist. Here, within the empty rectangle, it evokes all the others—the waters of the

Jordan, the Ganges, the Brahmaputra, and the Nile, the Amazon, the Mississippi and the Hudson—the rivers of sound throbbing in the wake of planets, the sap mounting in forests and across plains, and the blood that carries life made possible eons ago because on this planet there was water. H_2O—without which we perish. Water—metaphor of the logic upon which all life is built: The pattern that connects the currents and the tides, the antelope and the oak, the roar of thunder and the spider's web to you and me. This is the generative source into which Lewis Rubenstein dips his brush. Creating in what T. S. Eliot describes as that "condition of complete simplicity (costing not less than everything)", it is an enterprise that demands an unforgiving coordination of hand and spirit with no margin for error, washing away the ego that yearns to control, manipulate, and ultimately destroy all meaning.

Water has served Lewis Rubenstein as medium and metaphor throughout his career, beginning with fresco. However, he explains, "—even when I was teaching fresco in the Boston Museum School, I used to go over to the Museum to do Oriental brushwork with Chie Hirano in the Museum's Asiatic department. I liked water-based media that you could not change, that impose firmness and resolution."

The sense of oneness that unifies earth, sky, and water is demonstrated especially in water-colors such as *Ashokan*, 1985 (Fig. 30); *Coming Storm*, 1988 (Fig. 34); and *Autumn Stream*, 1990 (Fig. 38); in ink paintings *Pilgrim Lake*, 1975, and *There Went Up a Mist*, 1982; part of the Creation Series, 1982 (Fig. 26); and provides the all-pervasive theme that integrates the Time Paintings, *Vassar Lake*, 1949, *Winter Lake*, 1966 (Fig. 2), *Water*, 1971 (Figs. 52, 53), and *The River*, 1972. Even when the medium is oil, the theme persists. In *Schoodic Point*, 1969 (Fig. 19) and *Oregon Coast*, 1975 (Fig. 21), sky and water seem to become one substance. In the latter painting, as well as *Reflections*, 1969-70, the solidity of earth is minimized, revealed in shimmering reflections. In *Reflections* "wetness" dominates all form. The winter sky from which fresh snow has recently fallen is obscured in this woodland scene. Foreground snow, heavy and white, melts into an oblique pool that dominates the composition and emphasizes the impermanent, transitory flow of images. It is a world devoid of movement and sound, given over entirely to water, where form and substance create the heavy silence of winter.

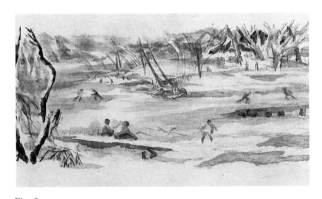

Fig. 2
Winter Lake, 1966
Watercolor on linen, 14 in. x 30 ft [scroll]
Time Painting
Collection of the artist

Fig. 3
Every Valley, 1959
Ink painting, 19 x 25 in.
Collection of Elisabeth and Alan Doft

The symbolic aspect of water is completely realized, however in the Time Painting, *Water.* From the velvety richness of the still depths, the painting moves gradually to pounding surf and an explosive energy where foam and sky unite. This is followed by a transition to new-fallen snow, heavy as it penetrates the waiting earth, and melts into a flowing stream. The cyclic aspect of nature is developed throughout the work by reference to the seasons, the times of day, by water evolving from clouds, mist, rain, and snow, into streams and rivers rushing toward the sea, where renewal begins again. Rubenstein's fluid brushwork and freely blended colors emphasize this process, accentuated from time to time by the contrasting permanence of rock forms or the shape of earth on the horizon, separating sea and sky. Occasionally the theme is punctuated by the presence of human and animal forms— the creatures of the deep, a gull that hovers above the surf, and the shapes of men and women who strain against the weight of nets as they drag life out of the sea. This "vocabulary of wetness" is carried even further in the *Creation Series* of 1982. In *There Went Up a Mist* and *Let the Waters Teem* a complete unity of form and content is achieved. Water has become the source of movement, shape, and color—the animating principle of life itself.

Patterns as Metaphor: Time

RM: Can you call to mind any work that was particularly seminal?

LR: You mean seminal in the sense of producing other works?

RM: Yes, perhaps representing a new direction.

LR: I'm thinking of a year when many things happened— 1948. I began doing Time Paintings. The first was *Winter Walk* (Fig. 39, 40, 41)—from which others developed. It was our first summer in Provincetown, when I got to know the dunes, and for many years thereafter I painted them. They became part of my vocabulary and I got to know them so well I could improvise with them.

Bateson points out that time and space do not exist in the mind, only *ideas* of time and space. But a major concern of artists—especially painters, composers, and poets—is to invent methods of representing what does not actually "exist," except as an idea in the mind. They accomplish

this by representing sequence and difference, modulation from one context to another, emphasizing "differences that make a difference."

Rubenstein developed Time Painting as an extended metaphor of his own experience. He, himself, loves to stroll through the natural world, contemplating its beauty, exploring its meaning, through the snow, across the shifting dunes, beside the flowing river. To retain this aspect of movement in time and space, he paints a continuous sequence of impressions on a long section of canvas—sometimes as long as 30 feet—rolled at each end like an Oriental scroll. With the help of a cabinet maker at Vassar College, he invented a frame with rolls attached on either side so that the painting is "unwound" gradually by the viewer through the upright frame from left to right. He has increased the complexity of this original process by filming the moving paintings, accompanied by music and poetry or, as in the *Psalm 104* painting, by spoken text. The whole is presented in the form of a video cassette—a new, multi-dimensional art form that Rubenstein has created. The "ideas" of time and space become transformed into an integrated, moving fabric that can be repeated endlessly.

RM: It occurs to me that, especially in the Time Paintings, there is a repetition of forms and rhythmic images that evokes a similar process in music and poetry.

LR: I guess I unconsciously think of rhythm in color, in certain forms, and certain shapes. I tend to work in a context of rhythm. If I'm using a certain color I'll instinctively use it somewhere else to give continuity, repeating the rhythm.

In *Winter Walk,* Chinese ink on canvas, contrasts are sharply drawn between the soft, yielding mass of snow and the brittle forms of frozen branches and twigs of trees. But, though "frozen," nothing is permanently fixed, neither the landscape nor the spectator moving through it. In this work the cyclic aspect of change is emphasized by an alternation of freezing, melting, and freezing again, forms that are at once still and moving, soft and brittle. The process and flow of time are immanent in the shifting reflections in pools of melted snow. At the end Rubenstein represents himself, a small figure moving away in the distance—moving on to other considerations—his "signature."

Rubenstein with a Time Painting, c. 1957

Fig. 4
Main Street (detail), 1954-56
Watercolor on canvas, 15 in. x 30 ft. [scroll]
Time Painting
Collection of Joan and Jonah Sherman

In his *Dune,* Time Painting of 1959 (Figs. 44, 45, 46), Chinese ink on linen, the style has changed considerably. The surface has been worked "wet" and the brushwork is free and flowing. There is a gradual modulation of tone, without the sharp contrast of the earlier work. Rubenstein is completely immersed in the shape and atmosphere of shifting sand and blowing grasses.

RM: Can you identify what specifically intrigued you about the dunes?

LR: Well, the spatial world of its own, completely unlike any other space one lives in. To quote A. R. Ammons (whose poem *Corson's Inlet* accompanies the *Dunes* video presentation), "there are no sharp lines in nature." There are no sharp lines in the dunes, but a continuity that makes it ideal for a Time Painting. Space just flows all around you. You are the center of a circle and it gives you a sense of freedom.

In his poem, Ammons refers to "significance, like a stream, running through my work"; comparing mental activity, perception, the movement and changing shape of the dunes—the alternating order and disorder of nature—all are revealed in Rubenstein's Time Painting.

Departing from the context of nature, Rubenstein did a Time Painting of the unfolding panorama of city life in Poughkeepsie, N.Y., *Main Street* (Figs. 4, 42, 43). In this painting the colors are more vivid, the rhythm is sharply metric, evoking the noise and confusion, the clashing images of a city street. There is the sporadic interaction of people of all types and ages—often humorous—always sympathetic, as they pursue the daily round of activity. Children run, skip rope, and fly kites and older people pause for a few moments of gossip. Life, in all its rich complexity, is moving on through time.

This concern with human life progressing through time as a metaphor is present in many of Rubenstein's works. In *Chassidic Wedding* (Fig. 16) and *Good Friday* (Fig. 8), in scenes of men laboring and children dancing, he refers to the rites of passage that integrate human experience. They are the transitions that "make a difference." In *Good Friday* timeless figures, hooded and disguised, move in slow procession from within a Mexican cathedral. The sense of ritual and repetition is exaggerated by strong vertical lines and a succession of identical forms that create a solemn rhythm. Sharply contrasted black and white details

emphasize the dramatic context of this yearly enactment of the Passion of Christ that seems to signify as well the eternal human passage from birth to death.

Patterns as Metaphor: The Sacred Aspect

RM: Did you ever have a desire to visit the Sahara?

LR: No, but there may be some ancestral yearnings or association with the desert.

RM: The desert landscape expressing the spiritual aspect of nature?

LR: Yes, it does seem to possess a sense of the spiritual in the same way that a river does. The surprising thing is that when I'm painting on the dunes, or anywhere in the natural world by myself, I never feel alone or lonely, whereas sometimes in the midst of a group I do.

Bateson begins the introduction to *Mind and Nature* with a quotation from *The City of God* by St. Augustine:

"Plotinus the Platonist proves by means of the blossoms and leaves that from the Supreme God, whose beauty is invisible and ineffable, Providence reaches down to the things of earth here below. He points out that these frail and mortal objects could not be endowed with a beauty so immaculate and so exquisitely wrought, did they not issue from the Divinity which endlessly pervades with its invisible and unchanging beauty all things."[3]

Couched in the symbols of another epoch, this expresses the sense of unity between the biosphere and humanity, or the perceiving Self.

In *Chassidic Wedding* (Fig. 16), *Praise Him with Dance* (Fig. 17), and *Gleaners I* (Fig. 10) Rubenstein reveals how an "invisible and unchanging beauty" pervades, not only the natural world, but the activities of men and women. The gestures of daily toil are imbued with a sense of sacred meaning. To accomplish this he combines elliptical forms with a "dance of interacting parts" that calls to mind the metaphysical paintings of Pieter Bruegel the Elder and El Greco. For these and other painters of the Baroque and Mannerist periods, elliptical form had specific spiritual significance in reference to newly discovered planetary movement as well as the round of human existence—a

cyclic pattern that connects with spinning Buddhist prayer wheels and Islamic whirling Dervishes. In Rubenstein's paintings symbolic rituals and dances possess a significance that transcends all sectarian considerations. Repetitive, elliptical forms are present even in landscapes where the human figure is of minor importance or absent altogether, such as *Oregon Coast* (Fig. 21), *Catskill Twilight* (Fig. 23), *Schoodic Point* (Fig. 19), and *Iona Island* (Fig. 33), in which a sacred element pervades all the "fearful symmetry" of nature. *Catskill Twilight* is viewed from above, as though perceived by a celestial eye. The light seems to emanate from within the mountains, the lakes and expanse of wooded slopes, giving one the impression of a world that is newly-created and innocent—a sacred image.

RM: Have you been aware of a process extending over many years that has dictated a change in the way you represent human figures? A direction leading from monumental shapes in the frescoes toward smaller, more anonymous figures in the landscapes?

LR: They definitely have become smaller and less dominant. When I use them at all I like to think of them as parts of nature. It would seem that, as subject matter, humans interest me less than nature.

The frescoes in the Germanic Museum (1935-1937) present man in the "Renaissance" mode. Oversize archetypes dominate the composition of the panels, with only sporadic references to the natural world in the background. There is, however, a "Baroque" expressiveness in the design that employs off-center composition, strongly contrasted diagonals, and the elliptical movement that continues as a motif throughout Rubenstein's work. In the *Currant Pickers*, 1964 (Fig. 14), the sense and direction of movement are similar, but the figures have been integrated with their environment. The technique of painting is lighter and more fluid. The faces of the anonymous figures are obscured by deep shadow.

In the Time Painting, *Psalm 104*, 1967 (Figs. 50, 51), human forms are almost completely absorbed by the landscape, creating a continuous fabric into which the words and images of the psalmist are woven. This Time Painting is reminiscent of the biblical illustrations of William Blake—to whom Bateson refers frequently— another "pattern" that connects him with Rubenstein. In *Psalm 104* Rubenstein uses natural forms as a

metaphorical reference to the cyclic nature of the span of human life, in which clouds and trees participate with man in a perpetual dance.

In *Oregon Coast*, 1975 (Fig. 21), man has diminished to a small shape lost in the immensity of nature—dwarfed by the sea and enormous boulders. But in the *Creation Series* man is eliminated altogether. Here there is a swirling mass of chaotic energy where the only reference to the presence of Man is the trace of the artist's brush.

In 1957-1958 Rubenstein received a Fulbright award to study and do scroll (*emakimono*) and ink (*sumi*) painting in Japan with traditional masters. This contact with the tradition of Zen served to emphasize *kukan*—literally "sky space," meaning space to be filled by the imagination, already latent in his work. The ink painting *Noh Dance* is an outstanding example of the work inspired by the year in Japan. But more important even than the technical mastery he gained from exposure to this ancient tradition is a gradually emerging condition in which Rubenstein becomes the ego-less instrument of the spiritual aspect of nature. In his most recent water-colors the essence of the natural world flows through him onto canvas or paper. There is no technical manipulation. The brush has become an extension of the artist's awareness.

LR: Often when I've been working out of doors for hours and am packing up my materials to leave I suddenly have the sensation that I've been in direct contact with whatever it is that is "out there" beyond our immediate perception. Then everything looks beautiful and I feel strongly a reverence for nature.

Form Is What Matters

In *Mind and Nature* Bateson comments that there is at present no existing science directed toward the combining of pieces of information.[4] Is it possible that this is precisely the function of art? To create an intelligible order out of seemingly disparate mental reflexes? To give them *form?*

One function certainly is to make visible the invisible connections of experience, to create visual metaphors for what lies behind the surface of events—of man's place in the scheme of things and his relationship to rivers and clouds, to the brilliance of an autumn day, and the deep silence of winter. Like the tiny, highly polished mirrors in

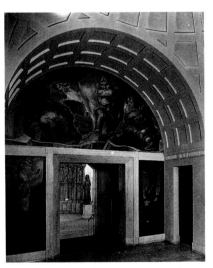

Germanic Museum frescos, 1935-37 in the entrance to Adolphus Busch Hall, Photograph courtesy, The Busch-Reisinger Museum, Harvard University Art Museums

Indra's net all these seemingly isolated events infinitely reflect each other, revealing those principles of organization that exist within the apparent chaos available to our senses.

LR: I believe the goal is not so much "self expression" as the possibility ideally to reach out to others and provide meaning for them.

To attain this goal as a teacher, Rubenstein went beyond the limits of his own work and in turn was influenced by the process.

LR: In painting I tried to aid each one to find his own direction. My own point of view had been very representational with a certain degree of realism, but in the years when abstract expressionism was important the students wanted to learn this style of painting. I felt I must understand abstraction even though it wasn't my own direction. In the process of doing that, I learned a great deal myself. I'm convinced that all good painting has an abstract base, even though it has the appearance of "things seen." And I believe my own work has benefited from a conscious effort to build that abstract base into it. That may explain my tendency toward including certain rhythms, and formal relationships that are not strictly representational.

The extended metaphor of a Time Painting goes beyond a sequence of brush strokes on thirty feet of canvas. It consists of more than images elicited by the "ideas" of water, dunes, and seagulls that make up the shifting patterns of nature. The painting is itself an instrument of change, nudging to wakefulness those regions of the viewer's brain that have so long slept undisturbed.

In confronting a work of art we bring with us the organizing principle of our own experience—encoded in the multitude of cells that compose an activity of cognition. Our patterns of recognition connect with forms dictated by the artist's vision—the "forms that matter" to both of us. Sometimes the result is a true awakening and the creative moment is passed on. Allowing this to happen is, in essence, what artists *do*. With remarkable skill, Lewis Rubenstein has learned to enhance and facilitate the process. His form has grown out of a gradual fusion of Western and Far Eastern traditions, directed toward the enhancement of his own expressive purpose. He has never resorted to short cuts. Inspired by diverse sources and spiritual traditions, his work has, over the years, become increasingly non-egoist and open to the natural world, allowing impressions to flow through him onto the paper, combining extreme discipline with spontaneous freedom. To all those fortunate enough to experience the ultimate result he brings a new awareness of the visible universe.

[1] Conrad, Joseph. *The Nigger of the Narcissus,* 1897. Harper and Bros. 1951 Preface p. xxxvii
[2] Bateson, Gregory. *Mind and Nature, A Necessary Unity.* Bantam 1988
[3] Bateson, p.2
[4] Bateson, p.22

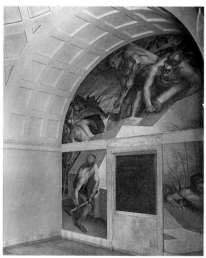
Germanic Museum frescos

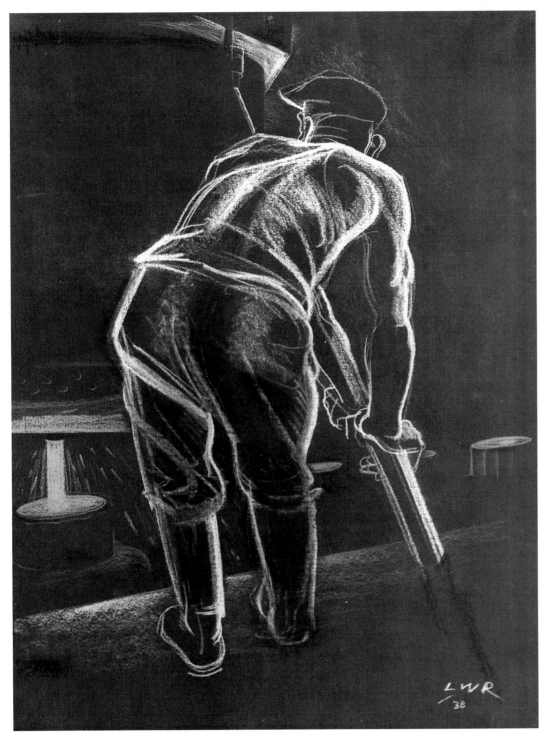

Fig. 5
Teemer's Back (also known as *Steelworker*), 1938
White, black and red chalk on black paper, 25 x 19 in.,
Frances Lehman Loeb Art Center, Vassar College,
Gift of the Art Majors of 1940 (40.8)

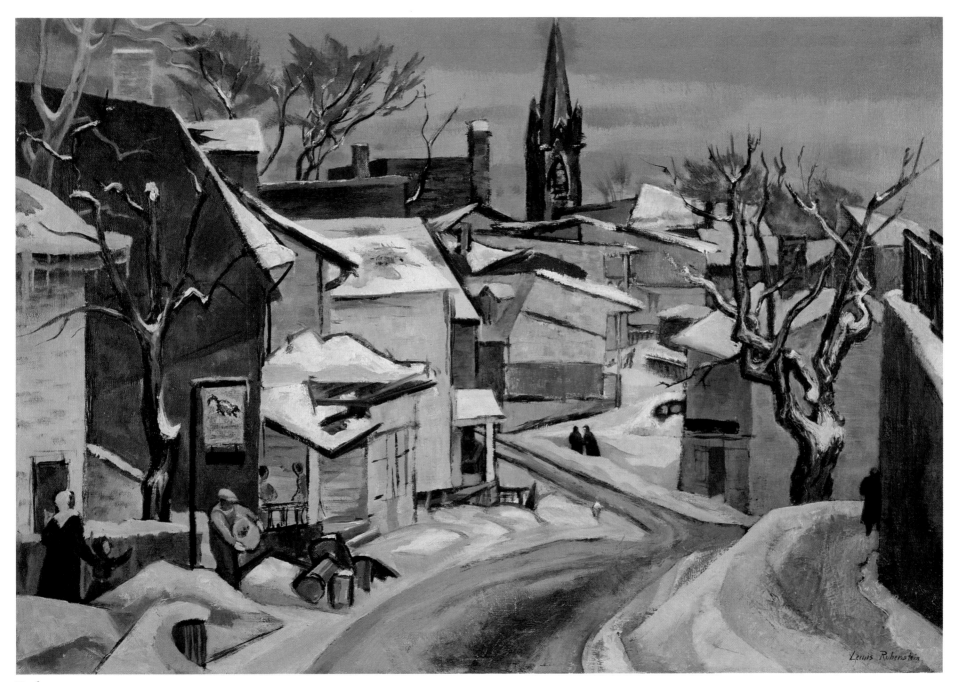

Fig. 6
Jefferson Street, ca. 1948
Oil on canvas, 25 x 36 in.
Collection of Marshall and Sterling, Inc.

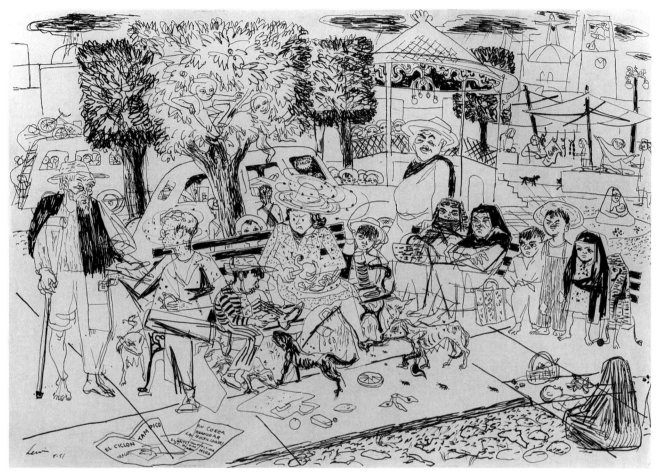

Fig. 7
Picnic in Mexico, 1951
Ink, 15 x 22 in.
Collection of Erica B. Rubenstein

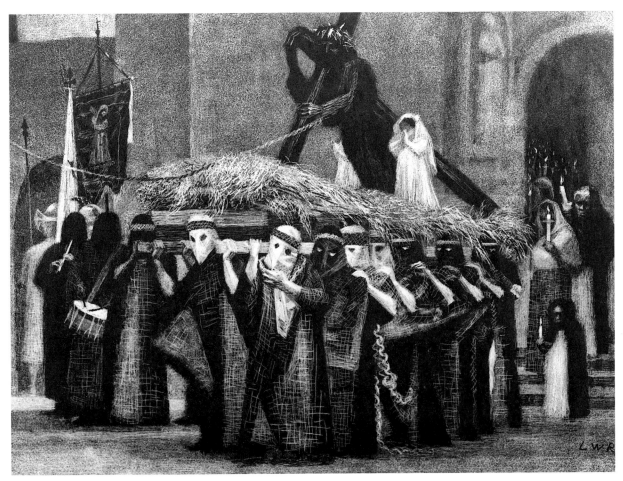

Fig. 8
Good Friday, 1957
Lithograph, 10¹/₁₆ x 14³/₁₆ in.
Collection of the artist

Fig. 9
Fishermen, 1957
Sumi, 24 x 37¾ in.
Collection of Lila Matlin and the late Dr. Melvin Matlin

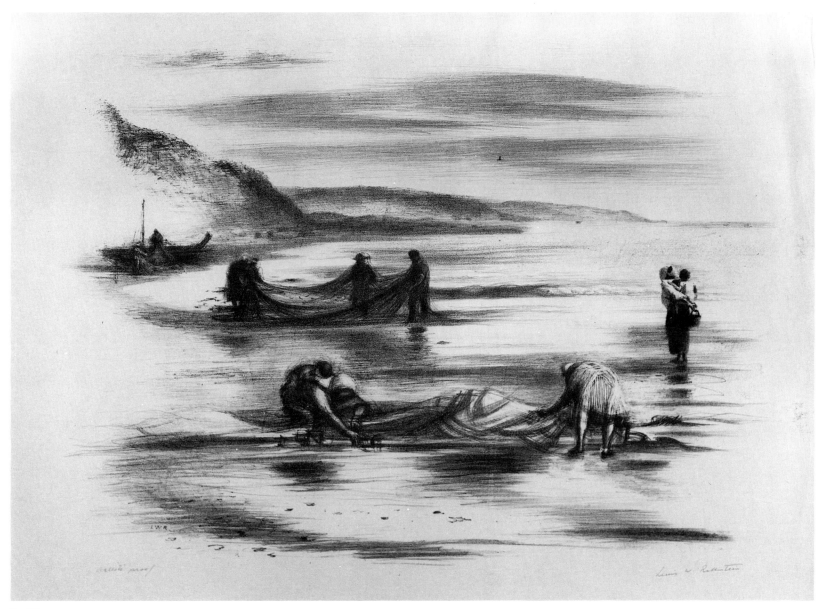

Fig. 10
Gleaners I, 1958
Lithograph, 15½ x 21¾ in.
Collection of the artist

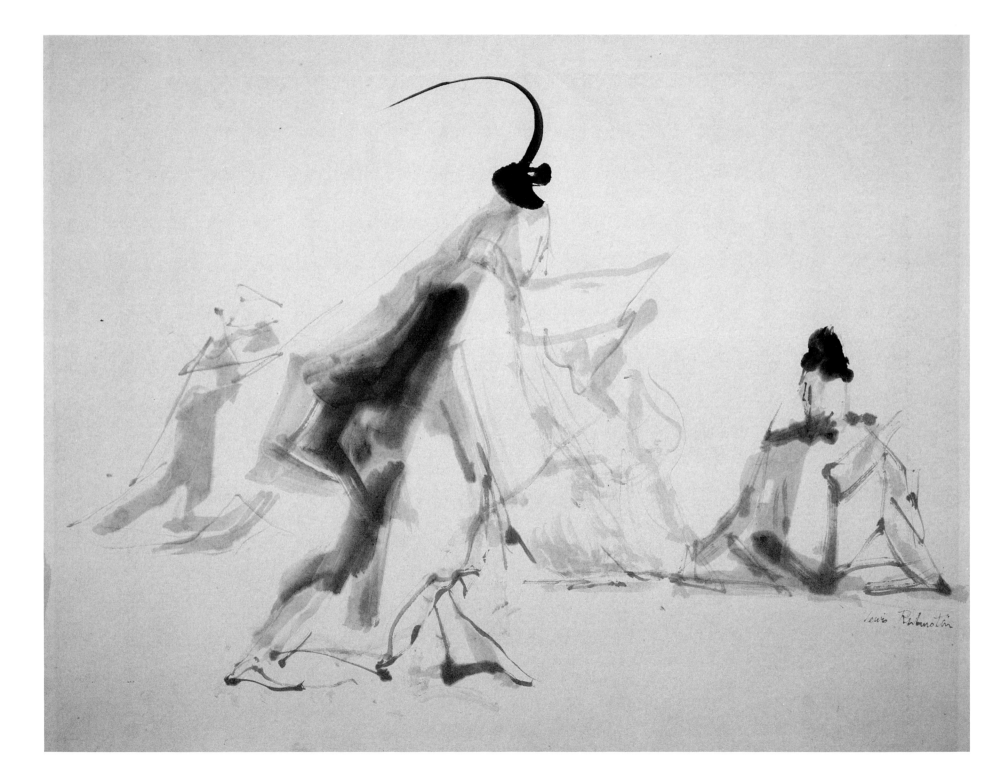

In looking back, it seems to me there have been three main threads running through the work I've done. The first is drawing. Second a liking for water-based techniques. These include watercolor, tempera, true fresco [buon fresco], *acrylic, but especially ink, or* sumi *painting....* *The third thread is that I've found the horizontal scroll form most sympathetic for my objectives in painting.*

Fig. 11
Noh Dance, 1958
Sumi, 26½ x 34¾ in.
Frances Lehman Loeb Art Center,
Vassar College, Bequest of
Jane Taylor Johnson,
Class of 1935 (81.30.10)

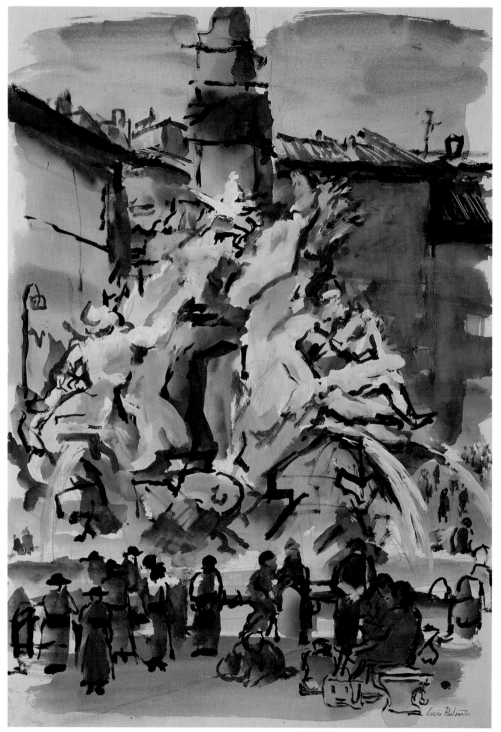

Fig. 12
Piazza Navona, 1963
Casein, 35 x 24 ¾ in.
Private Collection

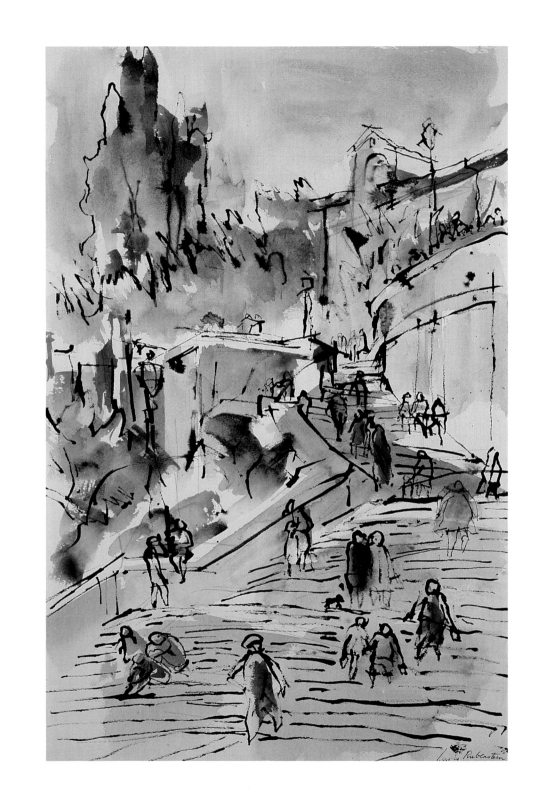

Fig. 13
Spanish Steps, 1968
Watercolor, 22⅜ x 14⅞ in.
Collection of Mr. and Mrs. Milton Chazen

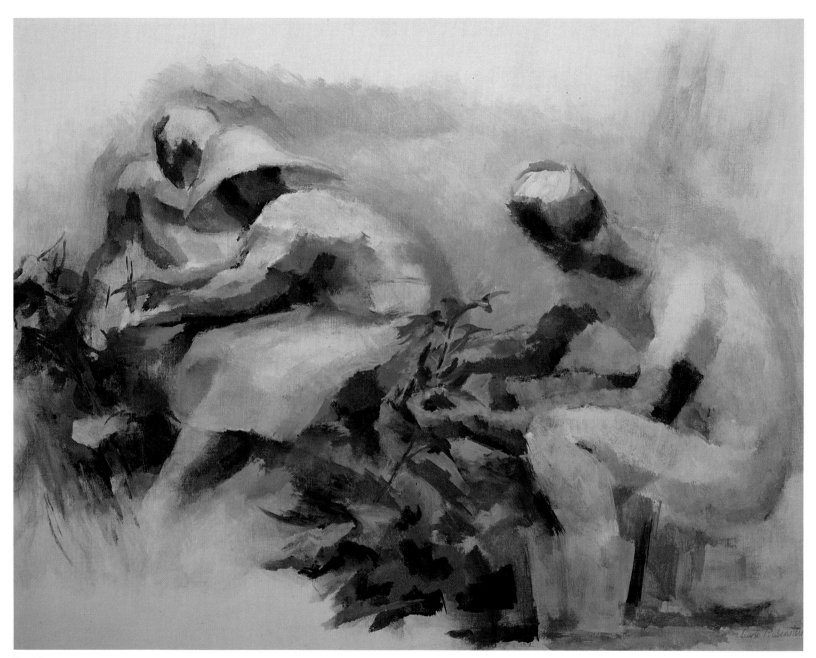

Fig. 14
Currant Pickers, 1964
Oil on canvas, 28 x 36 in.
Frances Lehman Loeb Art Center, Vassar College, Purchase,
Evelyn Borchard Metzger, Class of 1932, Fund (65.8)

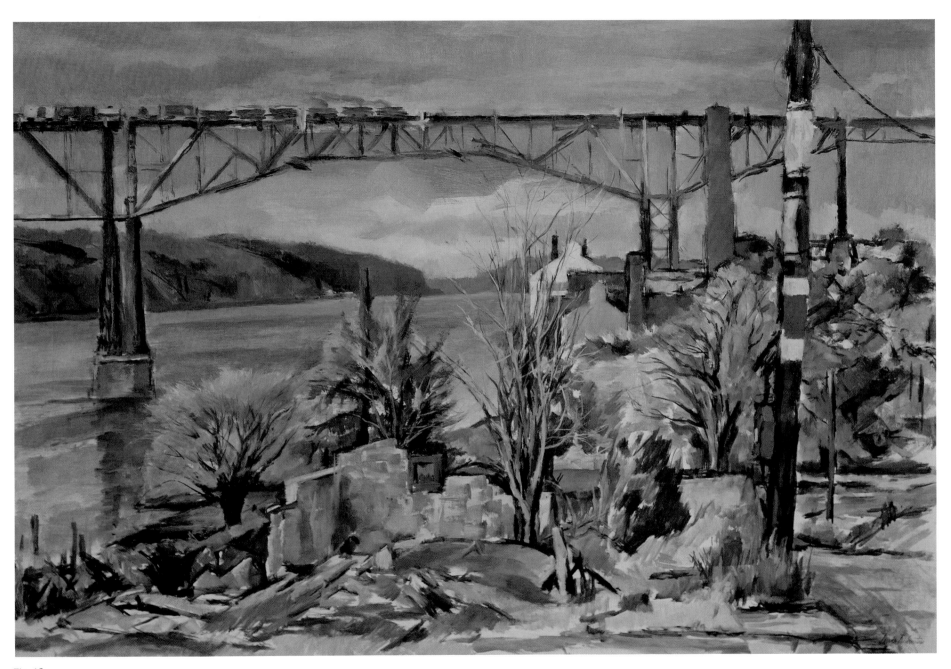

Fig. 15
Urban Renewal, 1967
Oil on canvas, 28 x 48 in.
Collection of Mr. and Mrs. Thomas A. Johnson, Jr.

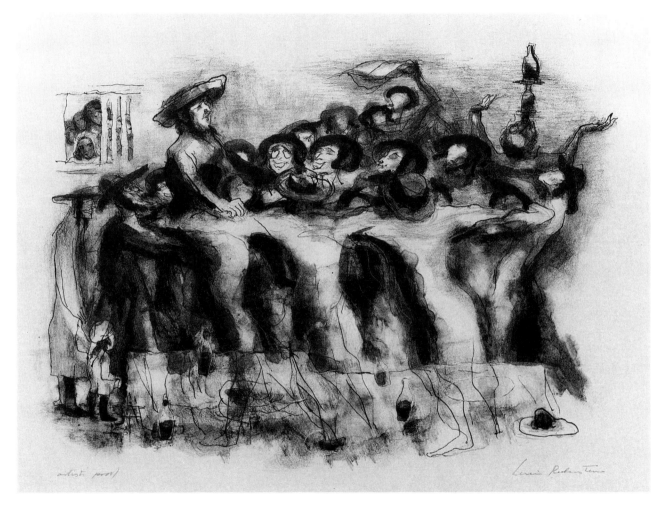

Fig. 16
Chassidic Wedding, 1968
Lithograph, 10 x 13¾ in.
Collection of the artist

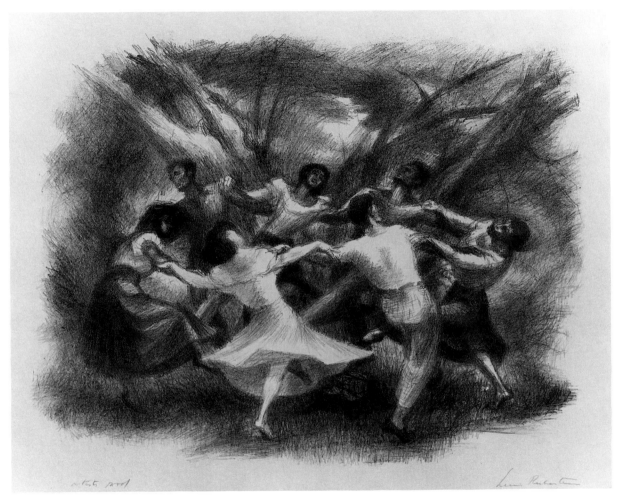

Fig. 17
Praise Him with Dance, 1968
Lithograph, 12¼ x 16 in.
Collection of the artist

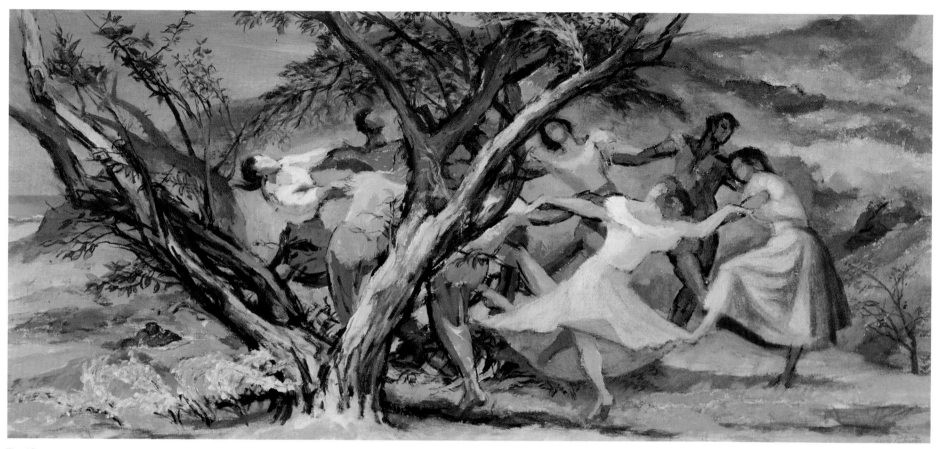

Fig. 18
Thou Renewest the Face of the Earth, 1968
Acrylic on canvas, 22 x 48 in.
Collection of Vassar Temple

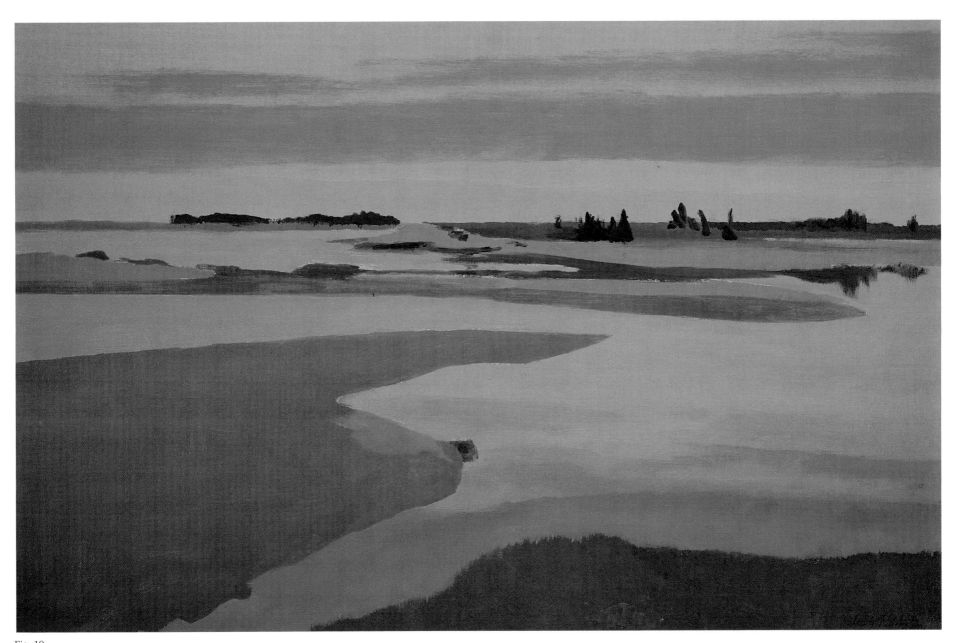

Fig. 19
Schoodic Point, 1969
Oil on canvas, 24 x 36 in.
Collection of Elisabeth and Alan Doft

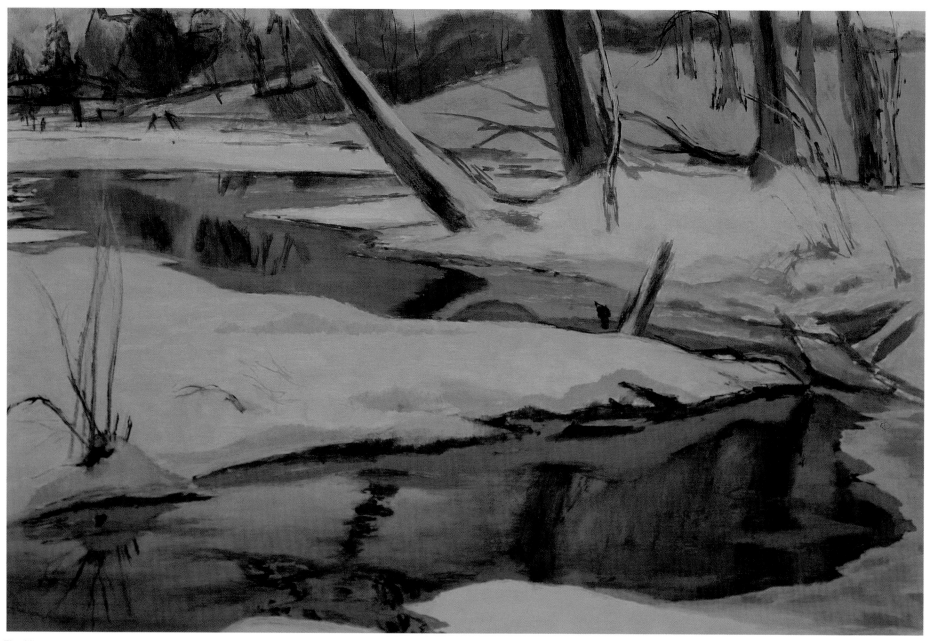

Fig. 20
Reflections II, 1974
Oil on canvas, 22 x 42 in.
Collection of the artist

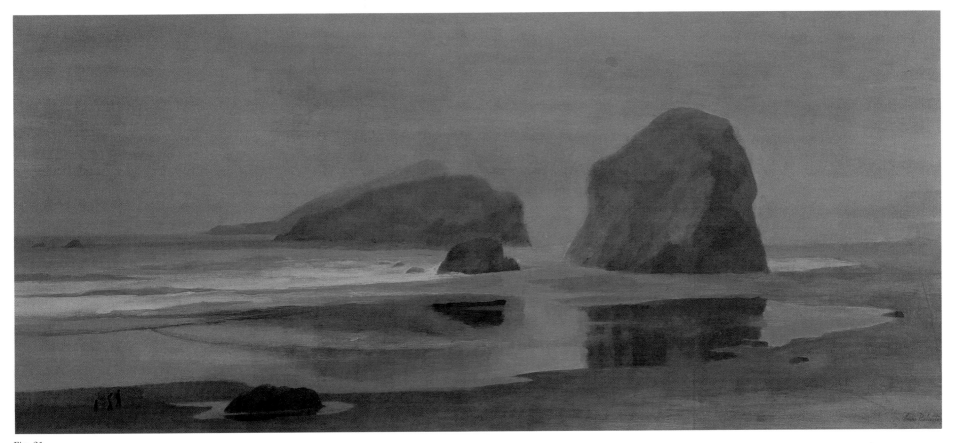

Fig. 21
Oregon Coast, 1975
Oil on canvas, 27 x 60 in.
Collection of the artist

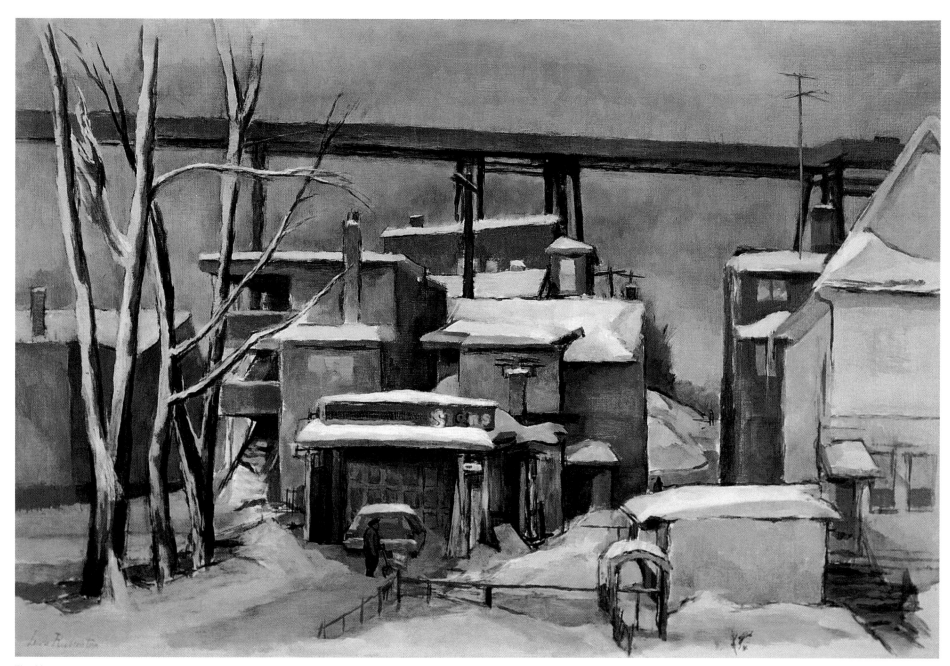

Fig. 22
Mount Carmel, 1978
Oil on canvas, 24 x 36 in.
Collection of Kingsley and Ann L. Morse

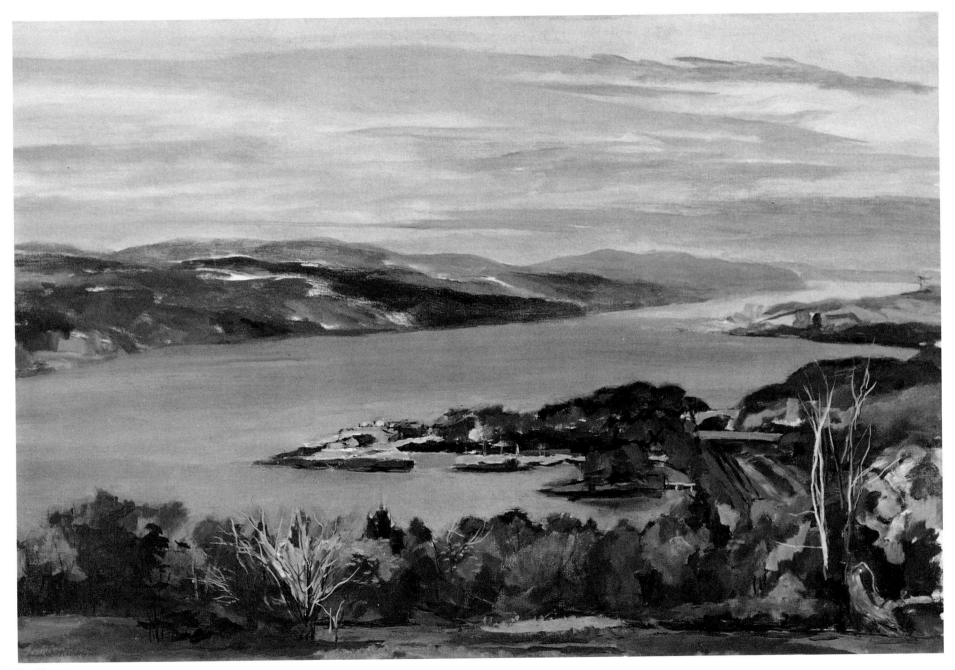

Fig. 23
Catskill Twilight, 1978
Oil on canvas, 20 x 30 in.
Collection of Mr. and Mrs. Charles E. Benjamin

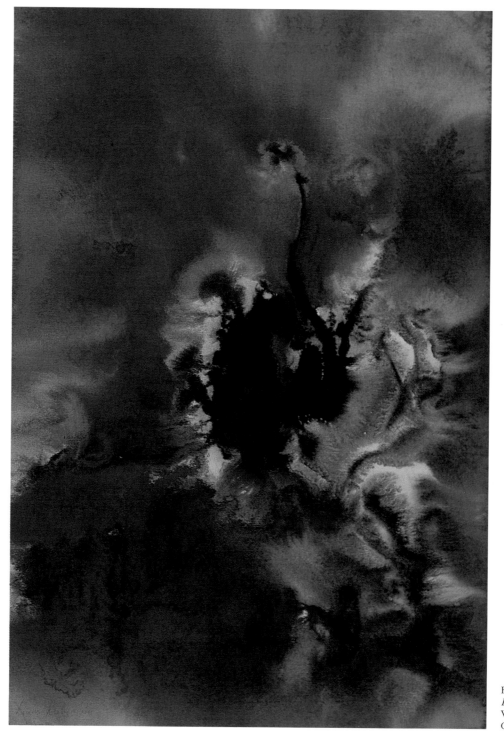

Fig. 24
Let the Waters Teem from *Creation Series,* 1982
Watercolor, 22¼ x 15 in.
Collection of the artist

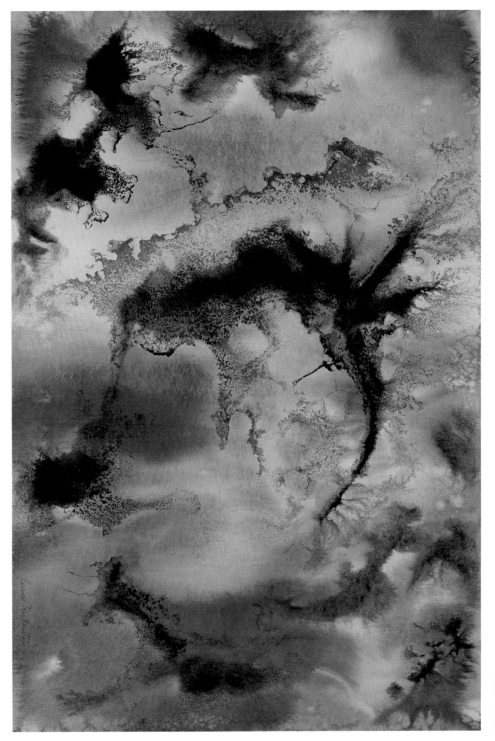

Fig. 25
*Who Stretchest Out the Heavens
Like a Curtain* from *Creation Series*, 1982
Watercolor, 15 x 22⅛ in.
Collection of the artist

While my own point of view in painting is essentially representational, my objective is an expressive use of nature. After many years of painting in both Western and Eastern modes, it's now pretty much one world for me.

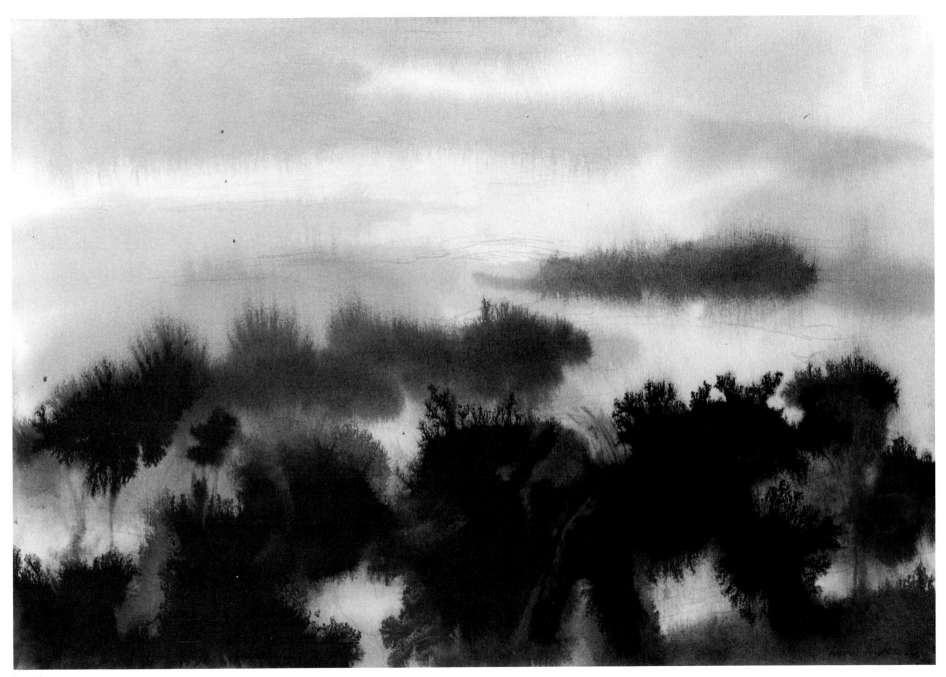

Fig. 26
There Went Up a Mist from *Creation Series,* 1982
Ink painting, 15 x 22 in.
Collection of the artist

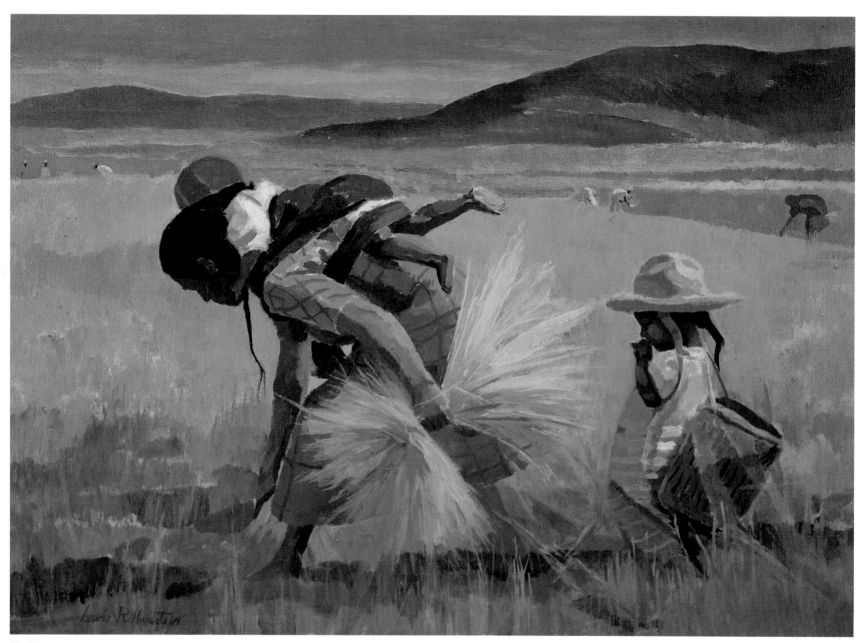

Fig. 27
Gleaners, 1983
Oil on canvas, 25½ x 35½ in.
Collection of the artist

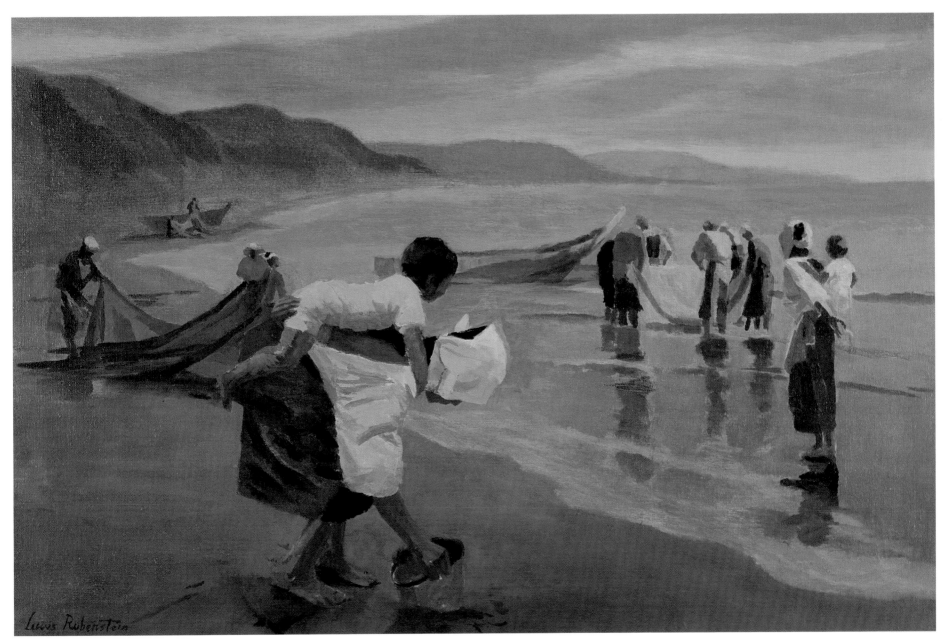

Fig. 28
Sea Gleaners, 1984
Oil on canvas, 24 x 36 in.
Collection of the artist

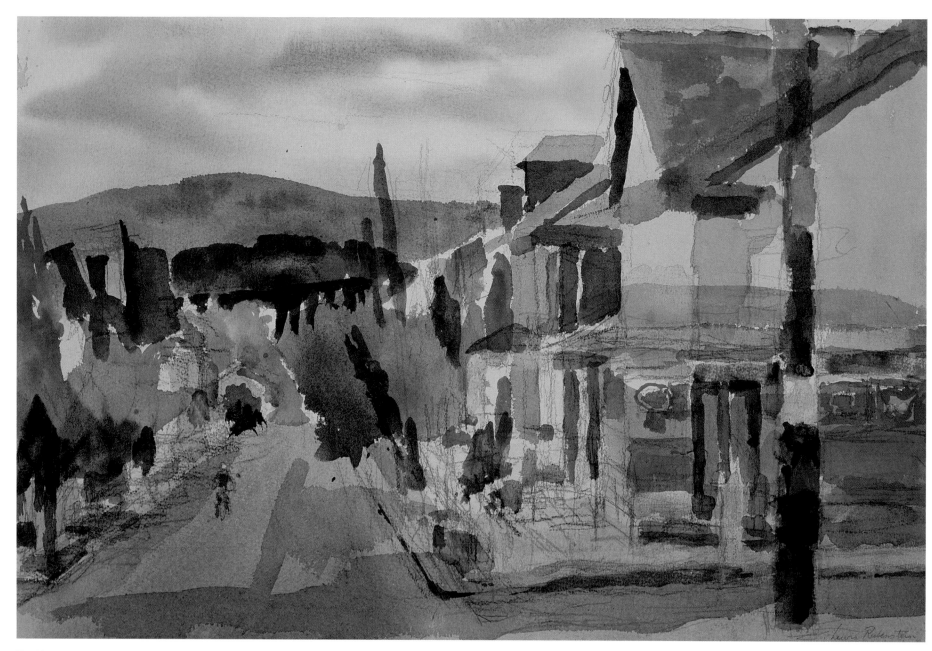

Fig. 29
Mill Street, 1984
Watercolor, 15 x 22⅜ in.
Collection of Patricia Wallace and Daniel Peck

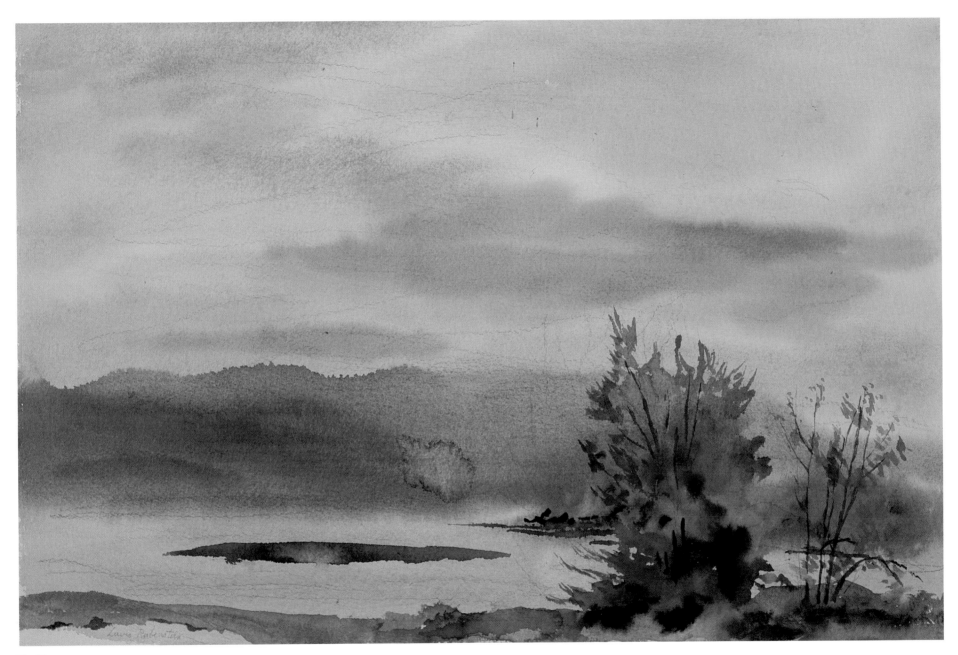

Fig. 30
Ashokan, 1985
Watercolor, 15 x 22 in.
Collection of the artist

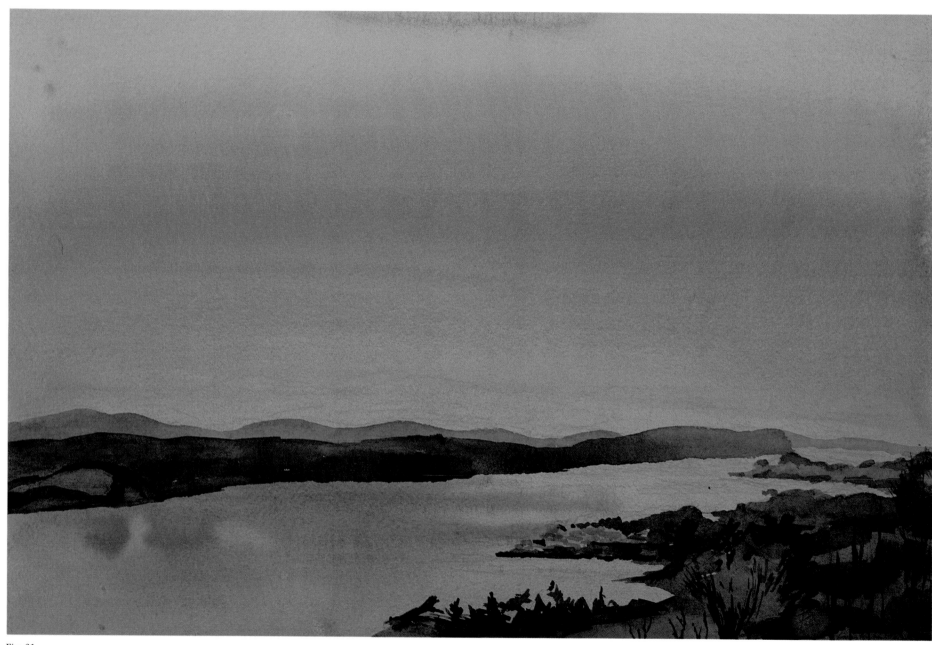

Fig. 31
Up River, 1986
Watercolor, 14¹⁵⁄₁₆ x 22⁹⁄₁₆ in.
Collection of Anne Parks Wood

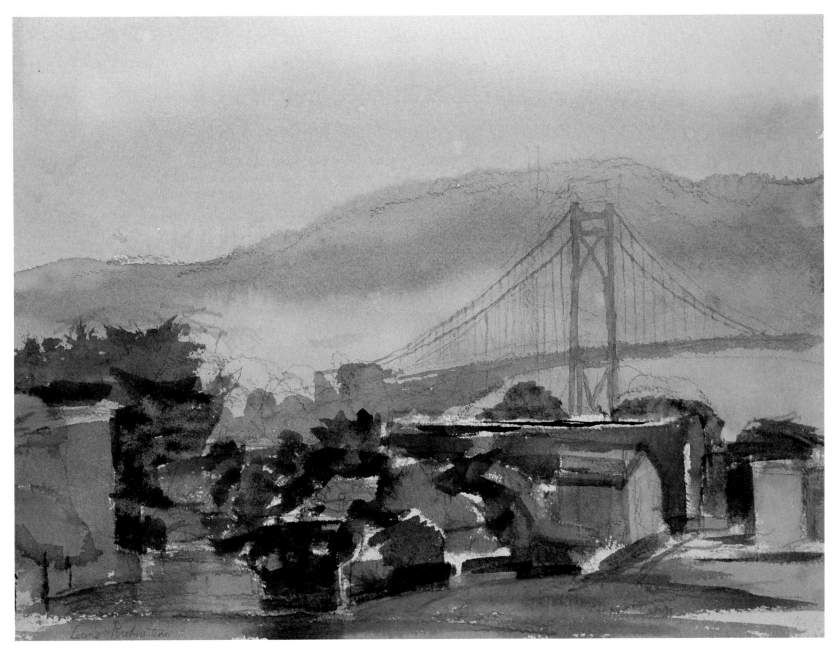

Fig. 32
Mid-Hudson Bridge, 1986
Watercolor, 11⅜ x 15 in.
Collection of Mitzi and Seymour Levin

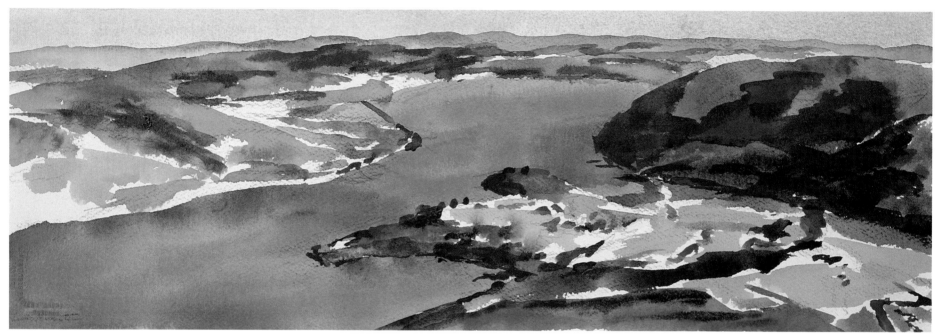

Fig. 33
Iona Island, 1988
Watercolor, 7½ x 22½ in.
Collection of the artist

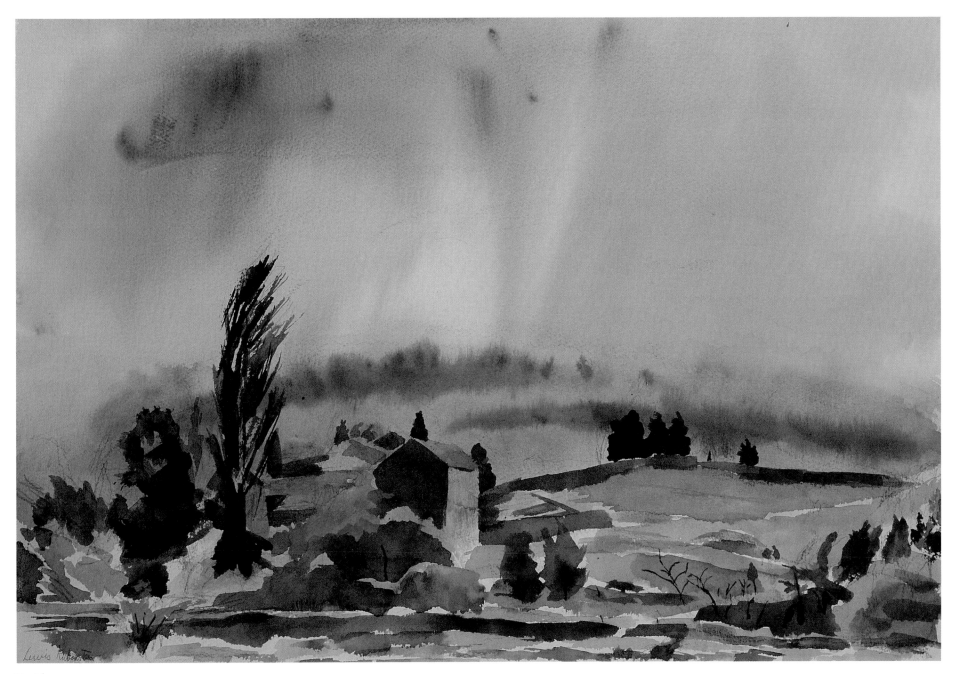

Fig. 34
Coming Storm, 1988
Watercolor, 15 x 22¼ in.
Collection of Phyllis Freeman and David Krikun

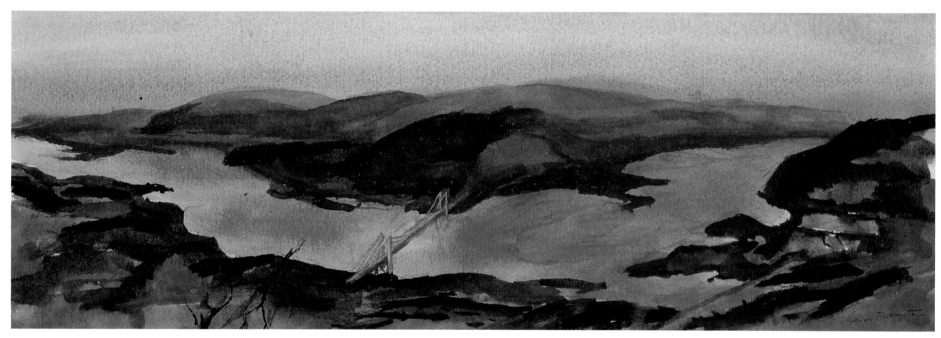

Fig. 35
Bear Mountain, 1988
Watercolor, 7½ x 22¼ in.
Collection of the artist

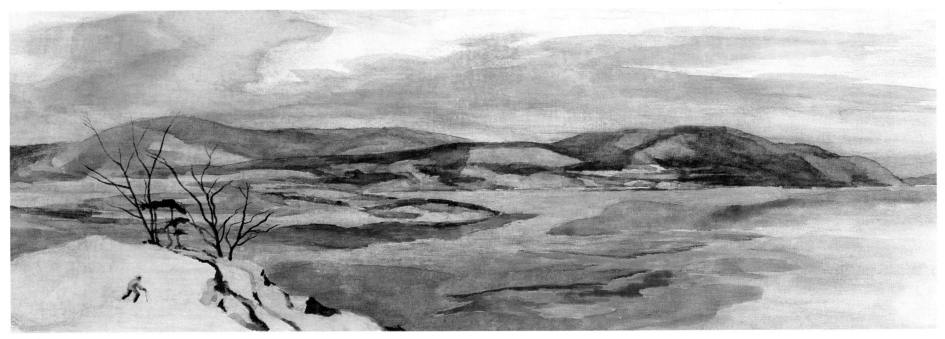

Fig. 36
Mid-Hudson, 1989
Watercolor on linen, 13⅛ in. x 21 ft. [scroll]
Time Painting
Collection of the artist

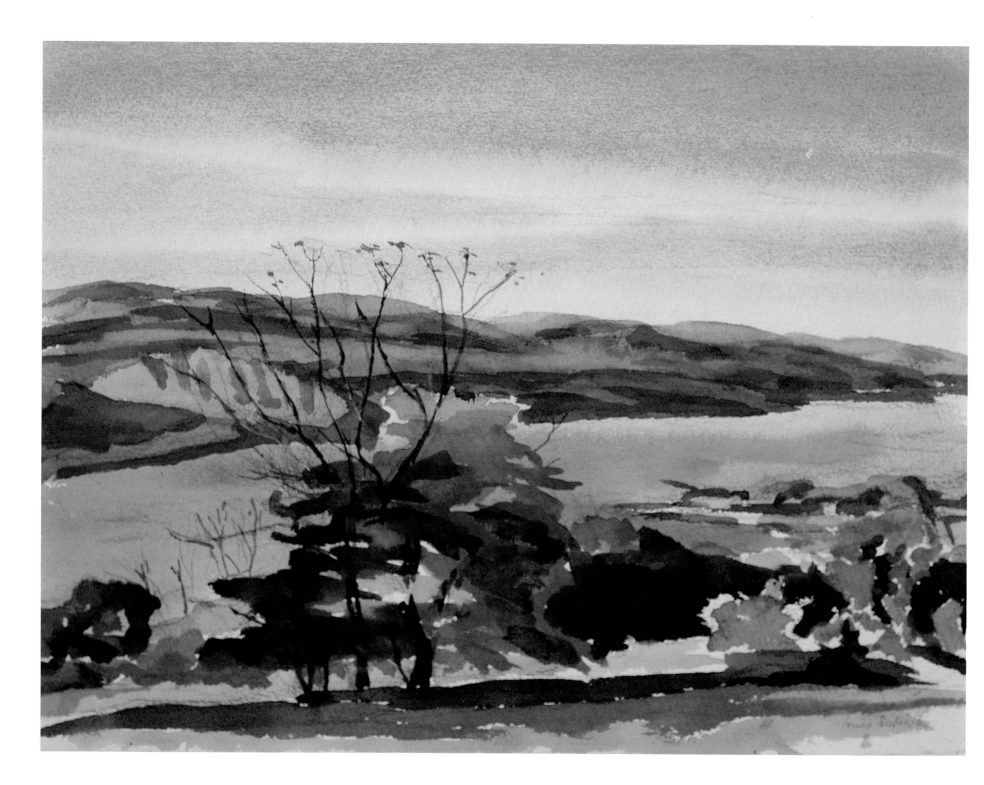

Watercolor, true fresco and sumi *painting are really performances in rapid time.*

The spontaneity begins the moment I begin to paint—it is here, once the planning is over, that I try to allow the work to impose its own direction, to dictate its own "flow."

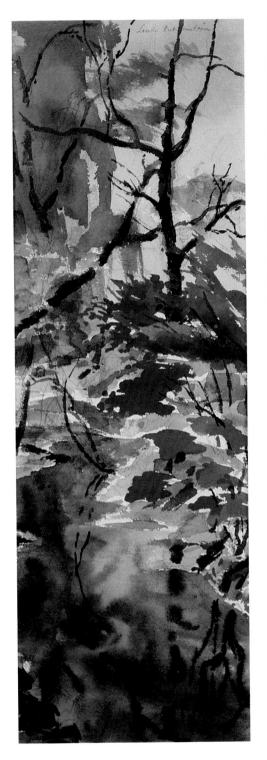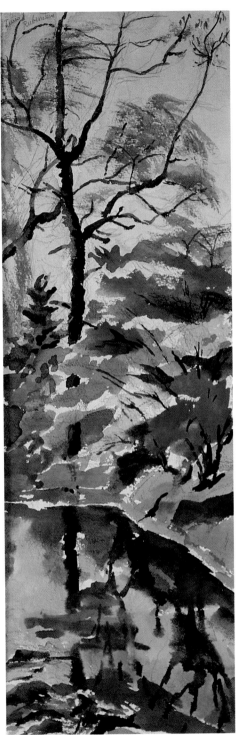

Fig. 38
Autumn Stream, 1990
pair of watercolors, 22 x 7 1/2 in. each
Collection of the artist

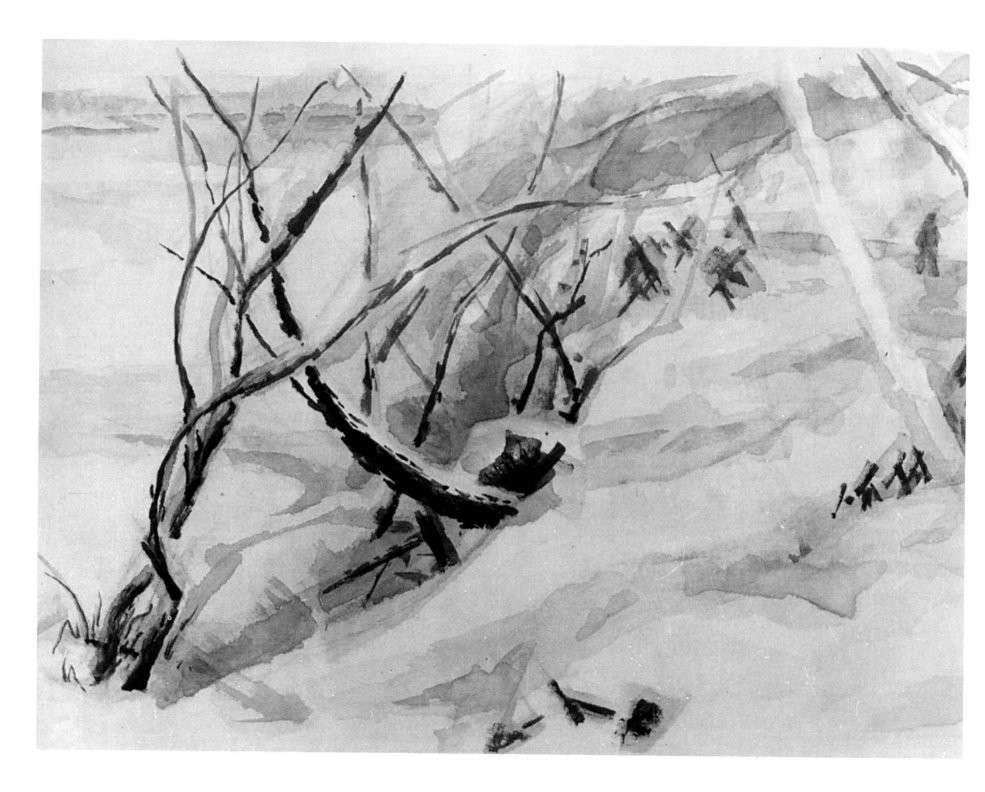

Time Paintings

Fig. 39
Winter Walk (detail), 1951
chinese ink on Acritex canvas,
15 in. x 17 ft. 5 in. [scroll]
Time Painting
Collection of Helen M. Land and
the late Dr. Edwin H. Land

Moving in Time: The Time Paintings of Lewis Rubenstein

Douglas Dreishpoon

Curator of Contemporary Art
Tampa Museum of Art, Tampa, Florida

Imagine a scroll painting, some thirty feet long and twenty-three inches high, housed within a frame-like structure. By slowly rotating one of the scroll's posts, images begin to appear in the frame's central window: a seascape with dunes; biblical scenes depicting nature's cycles of birth, growth, and death; even documentary images of a Western mining town. A progression of images pass through the viewing window. Within the frame the composition is constantly changing. Each scroll unfolds in time and space. Their resolution is their continuum; their end is their beginning. Is this the work of a traditional Japanese or Chinese painter? Hardly. These are the Time Paintings of Lewis Rubenstein.

Rubenstein first discovered Far Eastern scroll painting in 1926-27 when, as a student of Arthur Pope's at Harvard, he was introduced to the collection of the Boston Museum of Fine Arts. It was a revelatory experience, because thereafter the young artist began to experiment with ways of combining a horizontal scroll format with a traditional western frame. What intrigued him was the possibility of creating a continuous stream of related images that could be viewed sequentially. The basic concept had its roots in an earlier childhood experience. "As a kid," Rubenstein recalled, "I liked to do continuous drawings on rolls of paper with colored crayons, then I'd run them through a cut-out opening in a box in front of a lamp." What began as an adolescent fascination with comic strips and film eventually led to an extended series of works.

Over the course of about forty years, Rubenstein has executed more than thirty Time Paintings, whose subjects range from landscape and seascape to biblical and documentary themes. Each scroll tells its own story. Together they reveal a great deal about the artist. Any analysis of Rubenstein's work must take into account his Time Paintings. A significant part of his production, they incorporate themes and techniques that have characterized his development to date.

One of the best sources for understanding Rubenstein's art is the artist himself. While recounting his own history in a series of remarks recorded March 20, 1974, he made the following comment: "In looking back, it seems to me there have been three main threads running through the work I've done. The first is drawing. Second a liking for water-based techniques. These include watercolor, tempera, true fresco *[buon fresco]*, acrylic, but especially ink, or *sumi* painting....The third thread is that I've found the horizontal scroll form most sympathetic for my objectives in painting."

Drawing unites every aspect of Rubenstein's work, be it lithography, fresco or scroll painting. Drawing is a way for him to generate ideas, investigate compositional designs, and keep his art fresh. Indeed, drawing is the backbone of his creative process—its underlying principle.

As a young boy growing up in Buffalo, New York, Rubenstein used to sketch people in various situations and circumstances, aiming at a likeness or transcription of events observed. Later on, while attending night classes at the Albright Gallery Art School, he drew in charcoal from plaster casts. Drawing has always been the fundamental precept of a traditional art education. Before one was permitted to paint, one had to demonstrate a proficiency in drawing. Given Rubenstein's academic background, it is not surprising that his initial ambition was to be an illustrator and that drawing continues to be an essential part of his work.

Even in the Time Paintings, Rubenstein's preference for watercolor, acrylics, and *sumi* inks is based, at least in part, on their compatibility with drawing. His interest in Japanese brushwork and composition naturally led to an investigation of media that permitted a more empirical process. Most of the Time Paintings began as drawings—numerous studies that explore the dimensions of a given theme. (Actually, to describe this work as painting needs to be qualified; even though brushes are used, their application, and the results achieved, are akin to drawing.) During a visit to Rubenstein's studio last summer, I was shown how a Time Painting evolves through a series of thumb-nail sketches, each depicting a central motif within the general scheme. These become the basic frames within a continuous flow of images, a way of conceptualizing the sequential development of an idea.

In the act of executing a Time Painting, the artist proceeds quickly and deliberately, with a composite image in mind, but relying on intuition to make spontaneous adjustments when necessary. Continuity and improvisation are key. Having been a fresco painter, Rubenstein feels comfortable with a process requiring adept technique and intense concentration. "I do the final painting as I used to paint murals in true fresco," he recollected. "I finish a section a day, day after day. Like fresco, the scrolls can't be changed, so in doing a thirty-foot scroll it requires considerable discipline in order to sustain the spirit of the painting

Fig. 40
Winter Walk (detail)

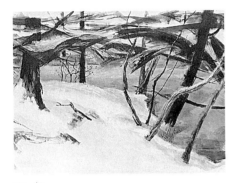

Fig. 41
Winter Walk (detail)

throughout." A similar control characterizes *sumi* painting, where the artist spontaneously applies inks to thin paper or parchment to avoid making marks that bleed. Both processes rely on sustained dexterity, a thorough command of the medium.

Although Rubenstein's scroll paintings share certain technical affinities with fresco painting, in other ways they differ significantly. Traditional fresco is an art of monumental imagery, a means creating larger-than-life tableaux for didactic or religious purposes. It is unlikely that Rubenstein ever aspired to the kind of heroic painting that came to be identified with postwar American art. The mural meant something different to him than to, say, Jackson Pollock or Barnett Newman, both of whom adapted its scale as a natural extension of their painting process. Rubenstein's rapport with the mural is more about technique. His conception of scale has always been intimate. This is especially true of the Time Paintings, whose unpretentious images seem to communicate in whispers.

Rubenstein has always preferred to work on a smaller scale, which is probably one of the main reasons he was attracted to Far Eastern scroll painting. Looking at examples of this art, many of which represent complex compositions with hundreds of figures or ethereal landscapes that seem to hover to infinity, one can easily understand how they impressed Rubenstein when he first saw them. Even the epic *Heiji Monogatari* scroll, whose dramatic scene "The Burning of the Sanjo Palace" greatly affected Rubenstein when he encountered it as a young art student at the Boston Museum of Fine Arts, is only 16¾ inches high. At that time he recognized the potential of this ancient art form.

Early on, Rubenstein realized his limitations as a Western artist when measured against traditional masters, some of whom—Maida Sesson and Keigetsu Matsubayashi—he later got to know during a trip to Japan, in 1957, on a Fulbright grant. So he adapted the technique, scale and format of Far Eastern scroll painting for his own expressive purposes. He began experimenting with watercolor and using linen instead of paper as a ground. Sized linen offered him a more durable surface better suited for his specially-constructed frame. This viewing device, a radical departure from Oriental precedents which are generally unrolled on the ground, has associations with the Jewish Torah, a parchment scroll containing sacred scripture. That

Rubenstein's Time Paintings, as objects, resemble Judaica is not surprising considering his persistent interest in biblical themes and the religious overtones of many Far Eastern prototypes. These not only became a natural vehicle for his own religious inclinations, but inspired him to develop a new pictorial entity.

Of the thirty Time Paintings Rubenstein has executed since 1948, about seven deal with biblical stories: *Passover*, two versions; 1950 and 1953; *Joseph and His Brothers*, 1952; *Psalm*, 1953; *Esther*, 1953; and *Psalm 104*, two versions, 1967 (Figs. 50, 51). *Psalm 104* has a special meaning for the artist, who described it as a summary of his artistic credo. In one sense, this Time Painting illustrates God's wondrous acts, the harmony existing between people, animals and nature. Its images can be seen as visual analogues for a sacred text, but its conception transcends mere illustration. Rubenstein drew on firsthand observations and a repertoire of visual recollections to compose this biblical narrative: sand dunes he walked over in Provincetown, Massachusetts; mountains he saw in Japan and Machu Picchu, Mexico; and gleaners he happened upon in a field near Oaxaca. These formed the basis of his narrative, a synthesis of experiences transfigured by time.

Rubenstein's Time Paintings are metaphors for the transience of temporal phenomena. In *Dunes*, 1959 (Figs. 44, 45, 46) and *Water*, 1971 (Figs. 52, 53), two of his most provocative scrolls, a series of suggestive images signifies dualistic forces in nature: form versus formlessness; light versus darkness; and stasis versus metamorphosis. Their ever-changing geography can be seen in phenomenological terms, as pictorial equivalents for empirical encounters with nature. I am reminded here of Maurice Merleau-Ponty's essay, "Cézanne's Doubt," where he described the painter's persistent immersions in the landscape as attempts to render on canvas ephemeral and fleeting perceptions. In some ways, Rubenstein's Time-Painting project shares a similar phenomenological orientation; each scroll is an attempt to map out an endless progression of change. To ponder the philosophical implications of this project is to acknowledge the transient nature of one's own existence, as an extended pause within a greater continuum.

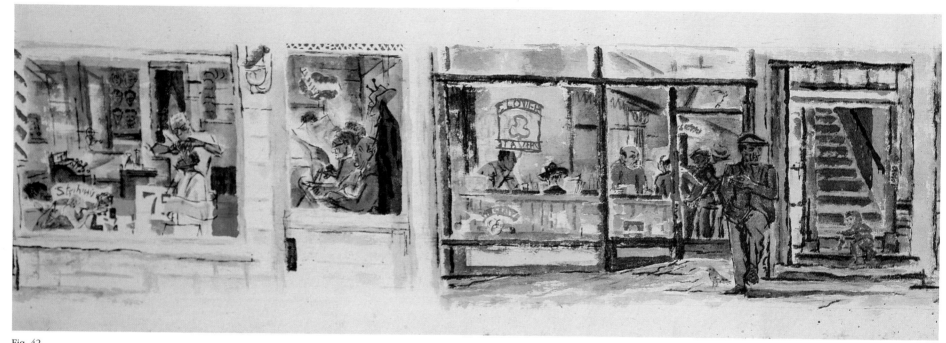

Fig. 42
Main Street (detail), 1954-56
Watercolor on canvas, 15 in. x 30 ft. [scroll]
Time Painting
Collection of Joan and Jonah Sherman

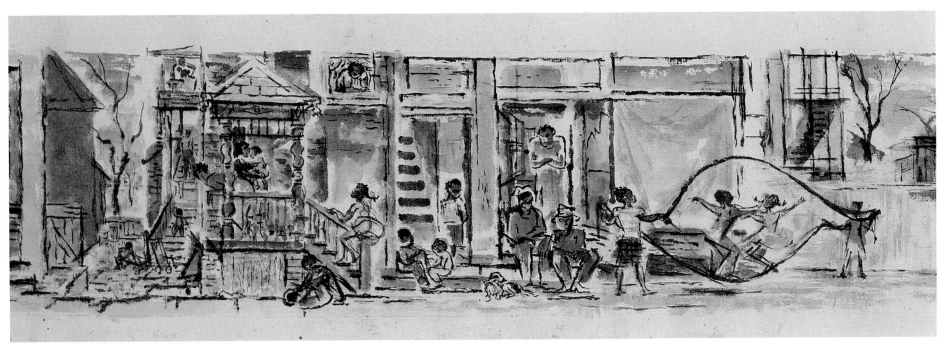

Fig. 43
Main Street (detail)

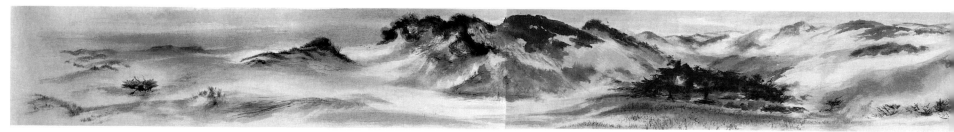

Fig. 44
Dunes, 1959
Chinese in on linen, 20¾ in. x 30 ft. [scroll]
Time Painting
Collection of the artist

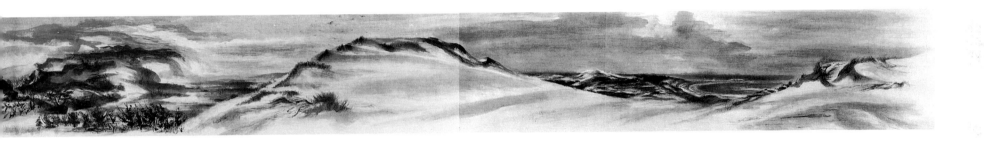

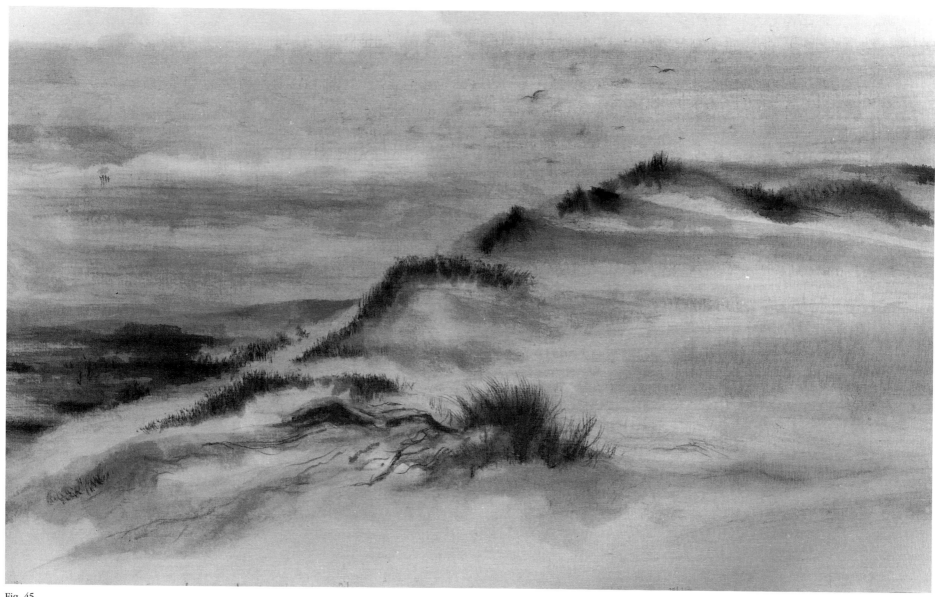

Fig. 45
Dunes (detail)

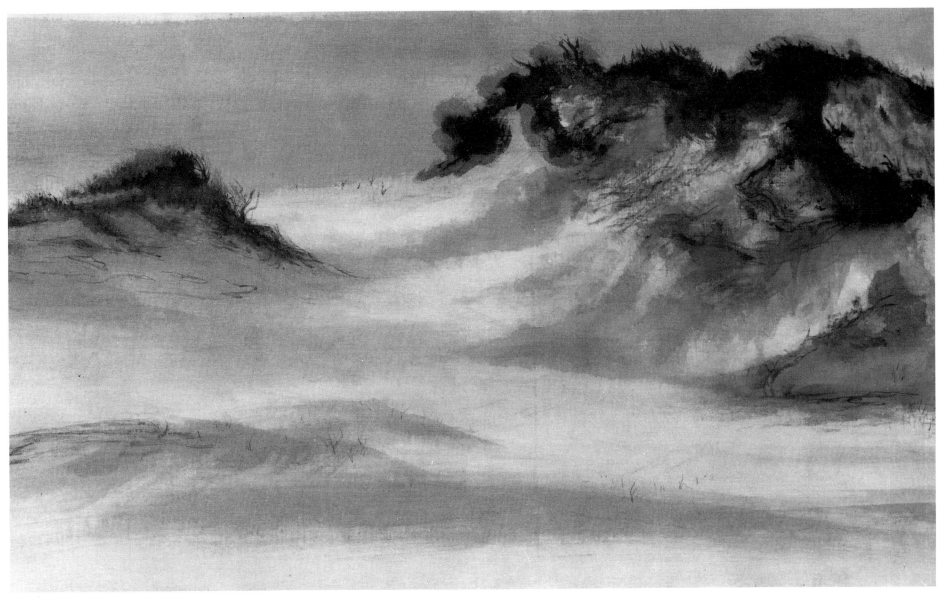

Fig. 46
Dunes (detail)

In about twenty-five years of work in Time Painting I believe I've made the scroll form a personal means of expression. I think the three threads—drawing, water-base painting, and the horizontal scroll form—tie together in my Time Paintings.

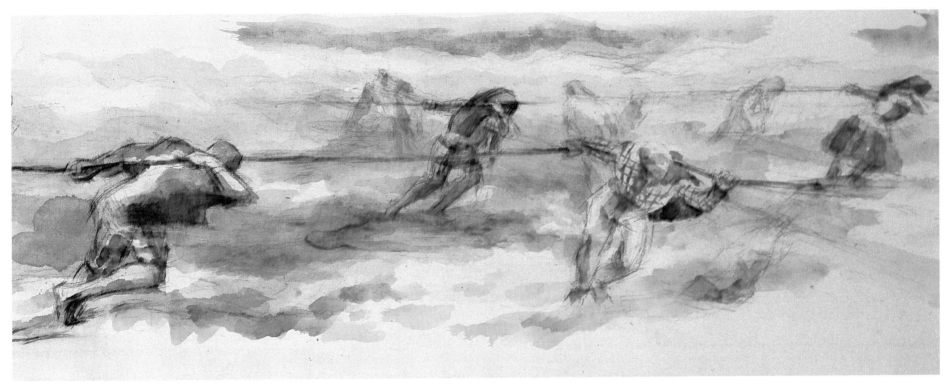

Fig. 47
Nazaré (detail), 1964
Watercolor on linen, 14 in. x 33 ft. [scroll]
Time Painting
Collection of Hyacinthe K. Hoffman and the late Harold E.
Hoffman

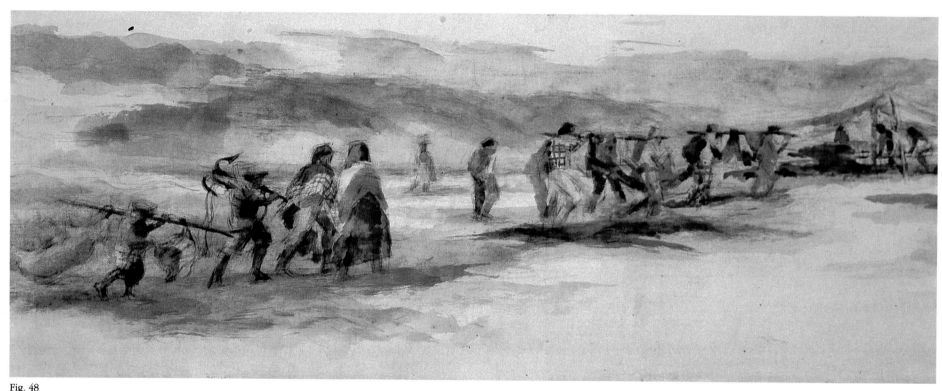

Fig. 48
Nazaré (detail)

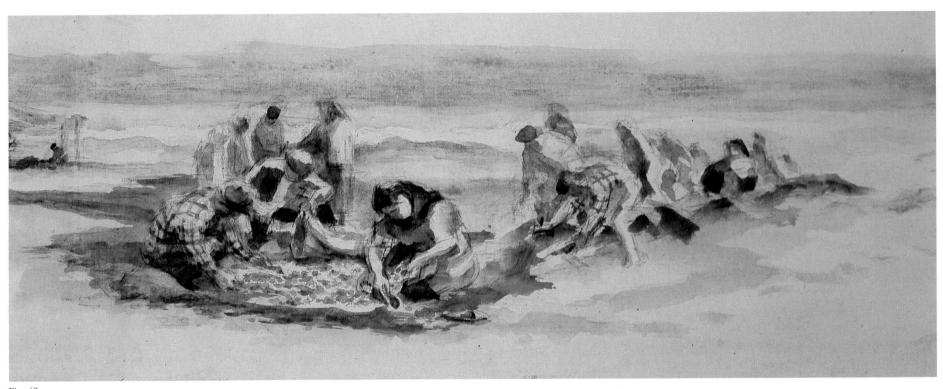

Fig. 49
Nazaré (detail)

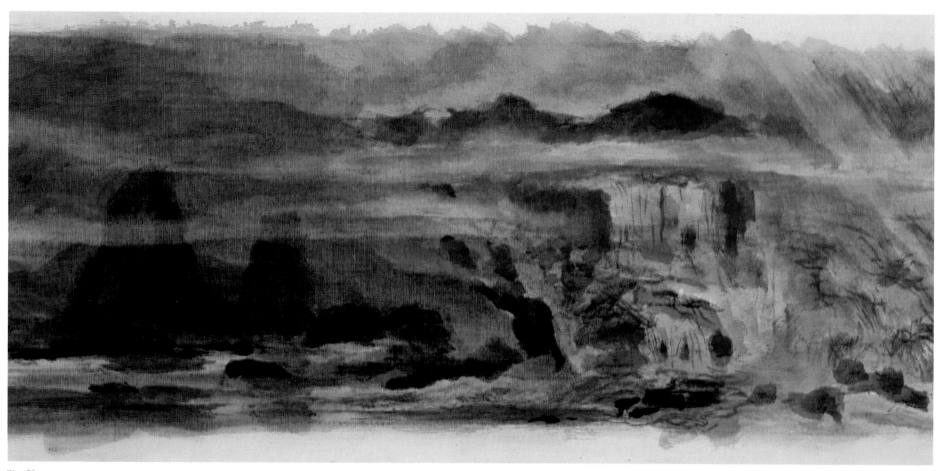

Fig. 50
Psalm 104 (detail), 1967
Watercolor on linen, 14 in. 33 ft. [scroll]
Time Painting
Collection of the artist

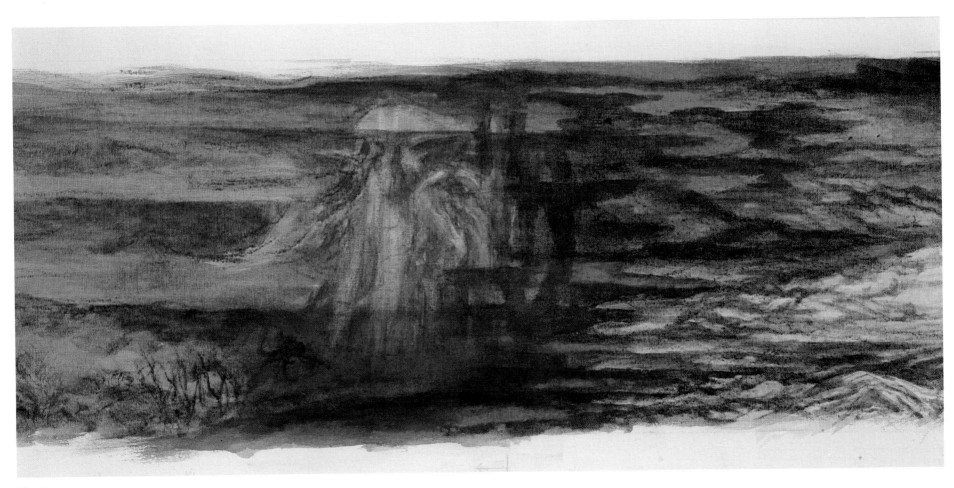

Fig. 51
Psalm 104 (detail)

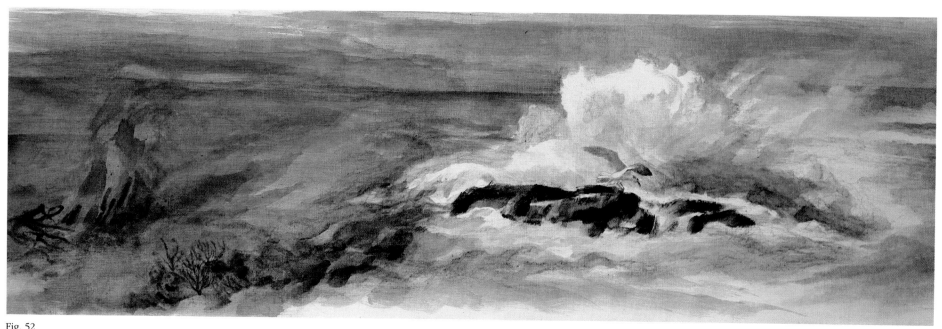

Fig. 52
Water (detail),1971
Watercolor on linen, 14 in. x 32 ft. [scroll]
Time Painting
Collection of the artist

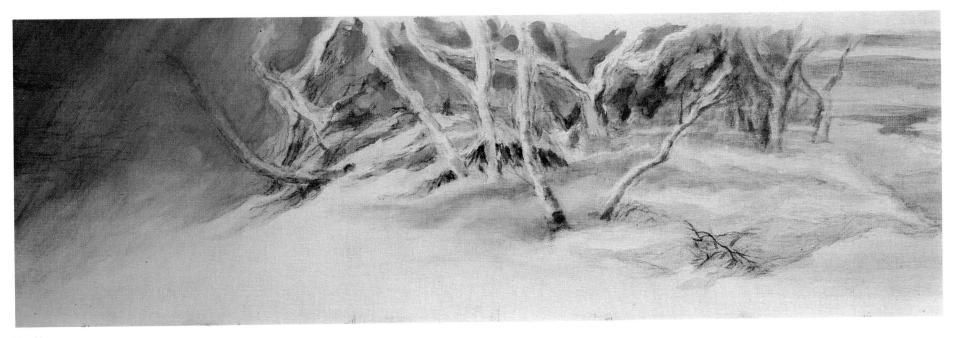

Fig. 53
Water (detail)

Chronological Biography

Rebecca E. Lawton

Curator of Collections
Frances Lehman Loeb Art Center
Vassar College, Poughkeepsie, NY

Rubenstein with his parents, c. 1910

1908-1918

December 15: Lewis William Rubenstein born in Buffalo, New York, the oldest of three children of Emil Rubenstein, a lawyer, and Hannah Hirschman Rubenstein. His paternal grandparents, Catherine Mayerberg Rubenstein and Louis Wolf Rubenstein emigrated from Lithuania, settling in Buffalo in 1867 and 1870 respectively. Rubenstein's mother's family is from Cincinnati. With his two younger sisters, Frances and Rena, Rubenstein is raised in a cultural environment. He loves to play sports and draws continuously in his free time. His interest in art is nurtured by his uncle, Jay (Harry) Rubenstein, who enjoys painting as an avocation, and also by an older cousin, Helen (Nessa) Cohen, a sculptor. One of Rubenstein's early memories is creating continuous drawings using colored crayons. He also recalls making humorous cartoons, comic-strip style.

c. 1920-1926

Attends evening classes at Albright Gallery Art School in Buffalo where he learns to draw in charcoal from casts. He is fascinated by books on Japanese art which he reads at the Grosvenor Library. Rubenstein's admiration for the *Saturday Evening Post* illustrations inspires his ambition to become an illustrator. While in high school, Rubenstein makes comics for the school's newspaper, as well as for his own enjoyment and the amusement of his family and friends.

1926-1930

Enters Harvard College, class of 1930. Not drawn to his father's profession, Rubenstein resists his father's suggestion to prepare for a career in law. He chooses instead to major in fine arts. While a sophomore, Rubenstein receives the Bower Prize for painting. The award convinces his father to allow him to become an artist. Through Arthur Pope, a professor of Fine Arts at Harvard, and Kojiro Tomita, curator of Asiatic Art at the Museum of Fine Arts, Boston, Rubenstein becomes acquainted with the museum's impressive collection of scroll paintings. Since Harvard's fine arts curriculum does not allow him the opportunity to concentrate in studio work, Rubenstein leaves college with a strong desire to further his training as an artist. Graduates cum laude.

1930

Summer: To earn money to travel in Europe, Rubenstein makes paintings of private homes in Bay Beach, Ontario, where his family has a summer house. September: Rubenstein leaves for Europe accompanied by Allan Rosenberg, a college friend. They travel tourist, 3rd class, on the *Statendam*, a Dutch boat, arriving in Holland on September 22. A few days later they leave for Germany and then travel to Italy. In late October they visit France and Rubenstein alone settles in Paris. The American artist, Walter Pach, advises him to study at the Academie Moderne where Fernand Léger and Amédée Ozenfant give weekly critiques. Pach cautions Rubenstein to "let [Léger] roll over you, then pick yourself up." Rubenstein finds

Léger stoical, but Ozenfant is "witty, talented and talkative." To afford the tuition, Rubenstein works as a class monitor and earns extra money taking photographs and making drawings for the *Pittsburgh Bulletin Index*. Rubenstein begins keeping a journal, a practice he continues almost daily throughout his life.

1931

Arthur Pope visits Rubenstein in Paris. Impressed with his studies after Renaissance paintings, Pope proposes Rubenstein for Harvard's Edward R. Bacon Art Fellowship for travel and study. June: Rubenstein receives a two-year Bacon fellowship. He remains in Paris until August 12, then visits England briefly before departing for Italy.

1931-1932

October: Rubenstein settles in Rome. Nessa Cohen introduces him to a fellow artist from the states, Rico Lebrun (1900-1964). They form a close friendship based upon their mutual admiration for Renaissance fresco painters such as Massaccio and Signorelli. Lebrun is an accomplished draughtsman and from him Rubenstein learns a great deal about drawing. Lebrun and Rubenstein study the "true fresco" technique with Silvio Galimberti. [In true fresco, painting is done directly on the damp, freshly plastered wall. The artist works quickly and carefully making sure to plaster only as large an area as he can complete in a single day's work.] June 9-16: Rubenstein and Lebrun visit Orvieto to study Signorelli's great cycle of frescos at the Orvieto Cathedral (1499-1504). July: Rubenstein arrives back in the States. Fall: He moves to Cambridge, where, as part of his Bacon fellowship, Rubenstein paints a fresco on the top floor of the Fogg Art Museum (now occupied by the museum's conservation studios). The subject is a figure copied from Signorelli's *Finimondo*. Winter: Rubenstein travels by bus to Washington, D. C. to join a hunger march. He makes numerous sketches and drawings during the trip.

Rubenstein and Rico Lebrun in
Galimberti's studio, Rome, 1932

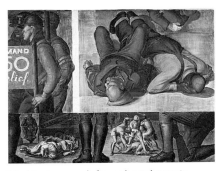

Washington march fresco by Rubenstein
and Lebrun, top floor, the Fogg Art
Museum, 1934

1933-1934

June: Lebrun returns from Italy. Rubenstein and Lebrun rent a studio in New York City, off Union Square. They share the ambition to paint murals in the tradition of the great Renaissance painters, using contemporary themes. Together they plan a mural based upon the Washington hunger march and make large-scale figure drawings using unemployed men as models. Spring: Lebrun and Rubenstein travel to Cambridge to execute the mural in fresco on the top floor of the Fogg Art Museum. The mural is a composite of each artist's drawings and they alternate responsibilities: one artist paints while the other does the plaster work and then reverse roles.

1934-1935

November 8: Rubenstein gives a demonstration on fresco painting at the Fogg Art Museum. Donates two books of drawings and watercolors to the museum. For the end of a basement corridor at the Fogg Museum, Rubenstein paints a third fresco, *Structure*, a scene of the construction of the wall itself, simultaneously showing the bricklayer, the plasterer and the mural painter performing their various tasks. Tanner Clark and Gridley Barrows, among other friends, assist with the work, loosely calling themselves the Guild of the Pineapple, a reference to Rubenstein's penchant for the fruit, as well as symbol of their apprenticeship. *American Scholar* (Autumn 1935) publishes Rubenstein's article "Fresco Painting Today," in which he argues the viability of fresco painting as a contemporary art form. He writes, "The great need is for murals that will deal constructively with the chaos and conflict about us, for works that will examine closely the forms of our world to find new meaning and new relationships in them." July 19: Rubenstein gives a lecture and painting demonstration on fresco painting at the Fogg and later that year on November 5, gives a similar lecture and fresco demonstration at the Metropolitan Museum of Art. Based upon his fresco work for the Fogg, Charles L. Kuhn, curator of the Germanic Museum at Harvard (later renamed the Busch-Reisinger Museum), commissions Rubenstein to execute two murals in true fresco in the foyer of Adolphus Busch Hall. The murals are funded by Mrs. Morris Loeb. Recalling a performance of Wagner's *The Ring* at the Metropolitan Opera, Rubenstein visualizes a scheme for the murals based upon subjects from Germanic mythology. Rubenstein begins work on the murals, assisted by Gridley Barrows, Tanner Clark and Channing Peake. Lebrun visits occasionally to offer advice. Harvard classmates such as Lincoln Kirstein and Edward M.M.

Warburg, who, along with John Walker III, had established The Harvard Society of Contemporary Art in 1929, also visit Rubenstein to examine the mural in progress.

1936

After completing the North wall mural—a scene taken from the Niebelung legend: Alberich driving his dwarfs to labor accompanied by symbolic representations of the Rhine Gold and the *Curse of the Ring*— a controversy ensues over its content; specifically over the fact that many of the figures are presented in contemporary clothing with modern accoutrements, leading viewers to conclude that the figure of Alberich—depicted in brown military breeches and riding boots—represents Adolf Hitler. *The Boston Herald* (January 31, 1936) reports that the murals are intended as criticism of Hitler and the Nazi regime, which causes a furor at the German Embassy. To avoid further controversy, Kuhn denies that the murals contain any symbolism. *The Boston Globe* (February 1, 1936) published an article on the murals under the heading "No Hitler in Mural at Harvard, It's Just Students' Imagination," but such press does little to end the controversy. Caspar W. Weinberger, class of 1938, an editor for the *Harvard Crimson* (October 31, 1936) writes that "[the murals] show the constructive and destructive forces of society opposed to one another, and may be classed as art in the highest sense, certainly detached from any suspicion of political significance." In order to complete the East Wall mural— "the Doom of the Gods," a scene of the Battle of the Gods and Giants from the *Ragnarok*, from the Elder Edda— Rubenstein distances himself from the conflict. He is briefly hospitalized while painting the East wall lunette when the mural's scaffolding collapses. Eventually, Rubenstein concedes to an interview for the *Boston Evening Transcript* (December 22, 1936) in which he states, "It [the figure of Albrich] is not Hitler or any contemporary figure. It is not the business of the artist to give political interpretations. Modern accessories are used to make the characters more vivid to people today. Renaissance artists did the same thing." At time of the unveiling of the murals, The Germanic Museum mounts an exhibition of Rubenstein's drawings and watercolors which opens on December 21. Harvard art historian, Frederick B. Deknatel, publishes an article on the frescos for the *Germanic Museum Bulletin* (March 1937). Deknatel praises the murals as a "real accomplishment" and cites Rubenstein's formidable powers as a draughtsman. He refrains from mentioning the debate over the content, stating instead that "the subjects are treated as an allegory

Structure fresco in progress in the basement of the Fogg Art Museum, c. 1935

Rubenstein giving fresco demonstration in Boston, 1937

of the destructive and constructive forces in society." After the controversy has dissipated, Rubenstein admits that he fully intended the murals be viewed as an anti-war, anti-fascist statement, and that the figure of Albrich specifically represented Hitler.

1937-1938

Winter: Rubenstein becomes interested in industrial subjects. Travels to Washington, D.C. and later visits Tennessee, Alabama and Louisiana. During the summer he visits New Mexico, Arizona and California. While in Jerome, Arizona, a small town of 6000 inhabitants in the eastern section of the state, Rubenstein lives in a dormitory with miners at the Phelps Dodge Copper Mine and makes a series of paintings and drawings of the miners. Rubenstein's portrayal of the miners is straightforward, based upon direct observation. Spends fall and winter in San Francisco. After returning to New York, Rubenstein meets Philip Guston (1913-1980), who is working for the WPA in the Mural Division. Lebrun moves to Southern California and settles there permanently.

1938

Spring: Rubenstein returns to Boston to teach fresco painting at the Museum of Fine Arts school. Chie Hirano, the museum's librarian in the Department of Asiatic Art, introduces Rubenstein to Japanese brushwork. He also begins working as a part-time consultant for the Polaroid Corporation founded by Edwin H. Land, a Harvard classmate and life-long friend. At a salary of $35.00 a week, Rubenstein works with birefringent colors and on three-dimensional films. The job continues until October; later in 1942 Rubenstein rejoins Polaroid to work in the anti-submarine program. May 4-June 1: The Germanic Museum mounts *Documentary Sketches by Lewis W. Rubenstein: Drawings and Watercolors of Life in an Arizona Mining Town and on the San Francisco Waterfront,* an exhibition of Rubenstein's western work. A review of the exhibition appears in the *Christian Science Monitor.*

1938-1939

Summer: Rubenstein rents a studio in New York. His interest in exploring new venues for expression leads him to study lithography with Emil Ganso (1895-1941), whose reputation for craftsmanship is legendary among printmakers.

1939-1940

Receives a one year appointment as an art instructor at Vassar College. Meets his future wife, Erica Beckh, a Vassar graduate, class of 1937, who is teaching art history at the college. Rubenstein prepares designs to submit to the U.S. Treasury Department's Section of Painting and Sculpture (later titled Section of Fine Arts) for the St. Louis, Missouri Post Office, one of the large national competitions. Based upon this work, he is awarded $900 to design a mural for the Wareham, Massachusetts Post Office. Edward B.

Rowan, the Section's assistant chief, writes to Rubenstein: "It is suggested that objective reality rather than abstraction be used for the decoration as [objective reality] is more readily acceptable to the public." Rubenstein chooses the annual cranberry harvest as the mural's subject and portrays migrant workers engaged in various activities associated with the harvest. He rents an empty store on College View Avenue in Poughkeepsie to draw the cartoons. The actual painting of the mural is done in tempera on canvas in Somerville, New Jersey, where Rubenstein stays with Tanner Clark's family.

April: Rubenstein exhibits a selection of his work at the Vassar College Art Gallery; included are drawings for his frescos at the Fogg and the Germanic Museums, as well as work from his western tour and his designs for the St. Louis, Missouri Post Office competition. The Art Majors purchase his drawing *Steelworker* of 1938 for the college's art collection. Rubenstein meets Poughkeepsie artist Thomas Barrett (1902-1947), whose home at 55 Noxon Street is later bequeathed by Barrett's sister to the Dutchess County Art Association (founded by Barrett in 1934), as headquarters for the organization's exhibitions and art classes. Rubenstein helps Barrett with his experiments in fresco painting and soon joins the lively association of artists dedicated to painting the local scene and exhibiting their works.

June: Rubenstein is hired to assist José Clemente Orozco (1883-1949), who has been commissioned by The Museum of Modern Art, to publicly execute a portable mural in the 3rd floor gallery in conjunction with the summer exhibition *Twenty Centuries of Mexican Art.* The mural, entitled *Dive Bomber and Tank,* is a semi-abstract composition, painted in fresco on six, interchangeable panels, each measuring 9 x 3 feet. When completed, the mural weighs 1½ tons and is sent on tour with the exhibition. Rubenstein supplies technical information for a

pamphlet on the project *Orozco Explains,* published in the *Bulletin of the Museum of Modern Art* (August 1940).

1940
Fall: Rubenstein does camouflage work for the Army's Passive Defense Project in Boston.

1941
Summer: Teaches fresco painting and Italian Renaissance art at the University of Buffalo. September: Rubenstein returns to teaching at Vassar.

1942
Rubenstein leaves to serve in the U.S. Navy where he is commissioned as a Lieutenant and stationed with the Bureau of Ships in Washington, D. C. Rubenstein is assigned camouflage work with Commander Charles Bittinger, John Marin's half brother. Bittinger arranges a lunch to introduce Rubenstein to Marin. Lacking much free-time and studio space, Rubenstein begins working in watercolor. June 28: Marries Erica Beckh in Brookline, Massachusetts where Erica has just received a masters in fine arts from Harvard and is working toward a doctorate which is awarded in 1944. The subject of her dissertation is "The Taxpayers' Murals."

1944
Harry Rubenstein dies.

1946-1947
February: Rubenstein rejoins the art department at Vassar College with a special salary grant from the trustees. Agnes Rindge Claflin, art department chairman, notes in her annual report to President MacCracken that Rubenstein had turned down an important offer from the United States Navy to continue special research as director of a permanent visibility theater at the David Taylor Model Base to rejoin the Vassar faculty. Moves into Rombout Apartments next to Vassar Farm; son Daniel is born on November 3. Rubenstein makes a survey of the studio art curriculum at various schools and colleges and begins visiting some of these programs. His work is included in the *Annual Exhibition of American Watercolors* held at the Museum of Fine Arts, Boston; *The National Drawing Annual at the Albany Institute of History and Art,* and the *Exhibition of Dutchess County Artists* and *Painters from the Dutchess County Area,* held at the State Teachers College in New Paltz. Rubenstein also has solo exhibitions of his watercolors and gouaches at the Friedman Galleries in

New York and the Vassar Cooperative Bookshop.

1947
October: Rubenstein begins experimenting with the idea of painting a continuous scene using the horizontal format of Asian scrolls encased in a special, manually operated, viewing frame, a concept he later calls Time Painting. October 17: visits Philip and Musa Guston in Woodstock. November 20: Rubenstein's journal comments "Tom Barrett died this morning, a sensitive painter for whom the struggle of living was too painful." December 22: Rubenstein's one man exhibition at the Norlyst Gallery in New York City opens. Though pleased to be showing his work, he notes in his journal,"Exhibits [are] a necessary evil." *Art News* publishes a favorable review of the show, "his academically trained eye looks for and finds the striking design offered by rolling hills and his academically trained hand dexterously translates it into paint." Rubenstein also begins showing his work at The Three Arts, a book and print shop in Poughkeepsie run by Jesse and Lee Effron. Thereafter, every two years until 1973, the Effrons mount exhibitions of Rubenstein's work.

1948
January: Rubenstein rents a studio at 385 Main Street in Poughkeepsie where he finds the life of the town stimulating as subject matter for his paintings. He paints the local scene including the older Poughkeepsie neighborhoods, such as Mount Carmel, and picturesque Poughkeepsie streets, such as Jefferson Street. March: Rubenstein juries the *Dutchess County Art Association Exhibition* held at the Vassar College Art Gallery. May: Rubenstein and his family go to Provincetown, Massachusetts for the summer where, under the G.I. Bill, Rubenstein is able to study with the abstract expressionist painter, Hans Hofmann (1880-1966), who runs a summer art school. Rubenstein's primary reason for attending Hofmann's classes in composition is to expose his Vassar students to the principles of abstract art. Rubenstein's journal notes, "His [Hofmann's] viewpoint seems to be the representation of the relationships of space and form in the subject; definitely *not* the subject itself. The representation of space and form is to be by two-dimensional elements *only*. All other means of representation he considers academic. It may well be that his teaching is just as academic in another direction. For me this emphasis seems negative: my material and educated predilection for living form is more or less realistic." Rubenstein becomes interested in painting the

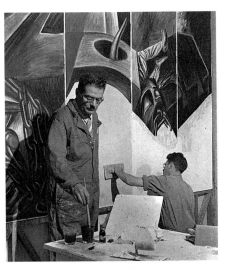

José Clemente Orozco with his assistant Lewis Rubenstein at work on *Dive Bomber and Tank,* June 1940 at The Museum of Modern Art, New York, during the exhibition *Twenty Centuries of Mexican Art,* May 15 through September 30, 1940. Photograph courtesy, The Museum of Modern Art, New York

Cape's sand dunes as he discovers that they provide an impetus to synthesize Asian and Western concepts. He enjoys walking over the dunes, committing their natural forms and rhythms to memory, and later using his imagination to improvise a composition based upon the experience. Fall: Rubenstein returns to Poughkeepsie to resume teaching and moves into a spacious, well-lit studio attached to 153 College Avenue which had belonged to C. K. Chatterton, who taught art at Vassar from 1915 to 1948. November 19-December 8: one-man exhibition at the Albany Institute of History and Art as part of the regional artists series. December 15: celebrates his 40th birthday. Starts reading Albert Schweitzer's *Reverence for Life*. Winter: Begins working a scroll panorama and continues experimenting with a simple frame mechanism for viewing the scroll paintings. Reads Schweitzer's biography of Johann Sebastian Bach and listens to Brahms *Requiem*. December 25-28: Trip to New York to visit the Asian collection at the Metropolitan Museum of Art and to see the Whitney Annual which he finds "depressing as usual." Returning to Poughkeepsie, Rubenstein begins experimenting with a completely abstract scroll painting in which he tries for the interplay of time-space relation, to dramatize shock value of contrasting forms, colors, space positions, to fill unpainted space with real tension and expectation…"

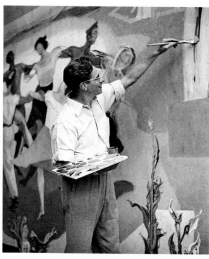

Rubenstein painting *Community Life* mural for the Buffalo Jewish Center in Ely Hall, Vassar College, 1949

1949

February 17: Gives fresco demonstration at Vassar and reflects upon how far he has moved from the Italian Renaissance painters and their formal viewpoint. Works on another Time Painting of Vassar Lake in winter. Rubenstein becomes increasingly distressed by a conflict within the art department over the curriculum which has been brewing for the past several years. Rubenstein sides with the art students who resent not being allowed to take more studio classes because of the departmental emphasis upon historical courses (Vassar did not yet offer a major in art studio). Rubenstein envisions expanding the applied arts program to include courses in other media, besides the traditional painting and sculpture classes. He notes in his journal "A conflict of two opposing viewpoints in education—the critical vs. the creative boils down to an opposition of two personalities, Agnes Claflin and myself." March 2: Rubenstein delivers a speech on the opportunity for studio art at a Vassar faculty meeting. As a result, he is elected to the Curriculum Committee. Unhappy at the amount of energy teaching and attending to administrative matters drains from his own creative work, but enjoys

contact with students. March 18-20: attends conference on art education at the Museum of Modern Art. Writes in his journal "As a teacher I believe the best art education for the general student or artist of college age is in a liberal arts college which permits the student to concentrate in creative work. As a painter I feel an identification with [the] search for reality, with human values, with vigorous expression with living forms. My viewpoint is similar to a painter of realism, humanism like Ben Shahn; opposed to the intellectual non-objective group." Rubenstein takes charge of a visiting artists program at Vassar; Stephen Green, Yasuo Kuniyoshi, Irene Rice Pereira, Ben Shahn, Philip Guston, Jack Levine, Fairfield Porter, Edwin Dickinson and Max Beckman, among others, come to campus over the next several years to talk about their work with students. April: Introduced to the 104th Psalm by Nessa Cohen in his college years, Rubenstein translates it from Hebrew.

June 13: Travels to Buffalo to discuss creating a mural for Veterans' Lobby of the Jewish Community Center and begins work on the design for the mural later that month. Rubenstein decides to use the hora as the central theme surrounded by images of music and storytelling. The final version of the mural, entitled *Community Life,* includes the motif of a young tree growing out of the cut down stump to symbolize the revitalization of contemporary Jewish life. He uses Erica and their son as well as his Poughkeepsie musician friends as models for some of the figures.

1950

January 18, Buffalo: Dedication of the Jewish Community Center mural which wins Empire State Architects Award. Spends summer with family in Wellfleet where he focuses upon painting the sand dunes.

1951

January: Awarded his first Faculty Fellowship to study mural painting in Mexico. Spring: Rubenstein becomes Associate Professor of Art at Vassar and is granted tenure. Rubenstein and his family leave for Mexico, traveling by car. Studies painting with José Guttierez. Also works in lithography at Taller Grafica in Mexico City. Visually stimulated by the relationship of the Mexican people to their surroundings, Rubenstein produces numerous drawings and eight lithographs of Mexican street festivals and religious ceremonies, as well as of scenes of laborers observed while driving through the countryside surrounding Oaxaca. September: Returns to Poughkeepsie.

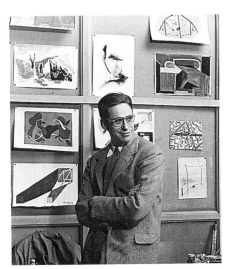

Rubenstein in his classroom at Vassar College, c. 1950s

Rubenstein showing *Ginza* Time Painting to Keigetsu at the International House of Japan, 1958

1952

January: *Good Friday,* one of the lithographs Rubenstein produced in Mexico, is awarded American Artist Group Prize at The 36th Annual Exhibition of the Society of American Graphic Artists (formerly, The Society of American Etchers) held at Kennedy & Co. in New York. Both the Metropolitan Museum of Art and the Rhode Island School of Design purchase the print. March 9: Rubenstein's father dies. June: Guillermo Rivas's article on Rubenstein's Mexican trip, which originally appeared in *Mexican Life* published in *Vassar Alumnae Magazine.* Summer: Rents a summer camp on Whaley Lake near Pawling. July: Moves to house attached to studio at 153 College Avenue. September 14: Daughter Emily born. October 12-November 11: exhibition in various media, including seven scroll paintings, at the Vassar College Art Gallery.

1954

Rubenstein and his family spend summer in Provincetown. Wins Society of American Graphic Artists' Knobloch Prize for his lithograph *Halberds.*

1955

Rubenstein takes family to Salem, Massachusetts for the summer. June: Attends his 25th year reunion at Harvard. June 13-July 1: Busch-Reisinger Museum mounts a retrospective exhibition of Rubenstein's work in conjunction with the reunion and sponsors a special lecture *Time Painting by Lewis Rubenstein, A Program of Moving Scroll Paintings with Music and Voice.* August: Works on television program of his Time Paintings produced by WGBH Boston; program includes *Mining Town, Winter Lake* and *Main Street.* November 1-27: one-man exhibition at the Berkshire Museum in Pittsfield, Massachusetts.

1956

Rubenstein receives a grant from Vassar's Salmon Fund for Faculty Research and Publication to make a documentary on his Time Painting. Rubenstein produces the 22 minute film with Josef Bohmer and John G. Holmes. October 27: film is shown on campus.

1957-1958

May: *Vassar Alumnae Magazine* publishes Erica's article on Rubenstein's Time Painting. Summer: Cape Cod with family. Fall: Both Rubenstein and Erica receive Fulbright grants to study in Japan. Rubenstein's award is to further his interest in *sumi* [ink painting] and *emaki* [horizontal scroll painting] by studying the technique with the Japanese *sensei* [masters] and Erica's grant is to study contemporary Japanese art. August: Rubenstein and his family arrive in Tokyo. The Rubensteins spend several days at Eiheiji, a Buddhist shrine near Kyoto, observing the Zen rituals and studying calligraphy and painting. Rubenstein works primarily with Keigetsu Matsubayashi, one of the foremost traditional painters. He particularly enjoys his association with Keigetsu. Also works in lithography with Onoya-San in Tokyo. The International House of Japan in Tokyo mounts an exhibition of his work.

1959

January: Exhibition of his Japanese work at the Vassar College Art Gallery. Summer: Cape Cod making ink paintings of the dunes which he later composes into a large Time Painting, *Dunes* . Receives the Fairfield award for *Mountain Lake* (an ink painting done in Japan), at the 10th anniversary New England exhibition of the Silvermine Guild in New Canaan, Connecticut. October 19-November 7: one-man exhibition at the Janet Nessler Gallery in New York. During the exhibition Rubenstein gives demonstrations of his Time Paintings at the gallery on Saturdays.

1961

Receives State Department Cultural Exchange Grant for a two-month residency in South America; visits Brazil, Chile and Peru to meet with artists and to paint the local scene.

1962

Vassar College Art Gallery buys *Vassar Lake,* Time Painting, using newly established Betsy Mudge Wilson Memorial Fund. State Department in Washington, D.C. mounts an exhibition of Rubenstein's work completed while on the Cultural Exchange Grant.

1963-1964

Receives his second Vassar Faculty Fellowship to study in Europe. June: Sails aboard the *S.S. United States* for France; Erica and the children join him in Spain later that month. Travels to Portugal then to Rome where he rents a studio on the Piazza Biscione along with other American artists.

1965

February 4-March 1: Exhibition at the Vassar College Art Gallery

One of a series of cartoons by Rubenstein commemorating the 50th Reunion of the Class of 1930 at Harvard, 1980, Collection of Chesley Dunlap

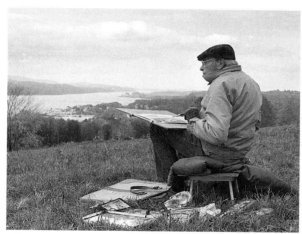

Rubenstein painting at Greystone, Wappingers Falls, 1989
Photograph: Eric Lindbloom

1966

March 29-April 16: Exhibition at Ruth White Gallery in New York City. Summer: Travels to Greece and Israel where he observes a Chassidic wedding on his first night in Jerusalem. He later uses the scene as the subject for a 1968 lithograph.

1967

Completes Time Painting of the 104th Psalm in watercolor on linen. Rubenstein considers this work a visual summation of his personal philosophy of living. "While my own point of view in painting is essentially representational, my objective is an expressive use of nature." The scroll begins with images of creation and recalls recurrent themes from his work such as of Mexican women laboring in the fields, hora dancers, and the Cape's dunes.

1968

January: Receives his third Vassar Faculty Fellowship to study in Europe, spends most of his time in Rome. Vassar Temple commissions *Thou Renewest the face of the Earth* in memory of Andrew H. Erdreich.

1970

February 11-March 13: Exhibition at the Vassar College Art Gallery; included are recent paintings done in Rome, Maine and Poughkeepsie. In the preface to the catalogue Rubenstein writes, "My own base is sort of an amalgam of elements from many traditions, Eastern and Western, including Oriental ink and scroll paintings; the wash drawings of Rembrandt and Goya; Italian fresco painters; Seurat and Cézanne. After years of working, I feel these differing directions are fusing into something that is my own."

1972

Ceremony for a New Planet, a film directed by James Steerman of several of the Time Paintings is produced; features poetry by Nancy Willard, and piano pieces by Todd Crow.

1974

May 5-June 7: *Retrospective Exhibition at the Vassar College Art Gallery* organized on the occasion of Rubenstein's retirement from teaching. Named Professor Emeritus of Art.

1976

December 15: Nessa Cohen dies.

1978-1979

Beatrice Schuller Cohen publishes "Lewis Rubenstein and His Time Paintings" in *American Artist* (November). May 2-May 27: One-man exhibition at the Dutchess County Art Association/Barrett House.

1980

June: Attends 50th reunion of the Class of 1930 at Harvard. Draws humorous cartoons to illustrate the event.

1981

Begins painting improvisations on the Biblical theme of Creation. He later explains to Raymond S. Steiner in *Art Times* (December 1984), that in the *Creation Series*, "the composition is carefully laid out and takes much time and thought. The spontaneity begins the moment I begin to paint—it is here, once the planning is over, that I try to allow the work to impose its own direction, to dictate its own *flow.*"

1983

October 8-November 5: One-man exhibition at the Dutchess County Art Association/Barrett House.

1986-1987

Receives a Dutchess Art Fund Grant from the Dutchess County Arts Council. Awarded the Dutchess County Executive Arts Award. Produces a video on Time Painting of *Psalm 104* which is accompanied by a musical score performed by Todd Crow and narration by Donald Wildy and Allelu Kurten.

1989

June 9- July 30: *Lewis Rubenstein: Watercolors* exhibition at the Vassar College Art Gallery, Warburg Print Room

1990

March 23-April 12: Dutchess County Art Association/ Barrett House mounts an exhibition of Rubenstein's work. September 9-October 15: *River, Field & Park,* a joint exhibition by Eric Lindbloom, Howard Knotts and Rubenstein at the Cunneen Hackett Cultural Center in Poughkeepsie.

1991

May 4: Harvard University Art Museums holds a reception to honor Rubenstein on the occasion of the restoration of the Busch-Reisinger Museum murals.

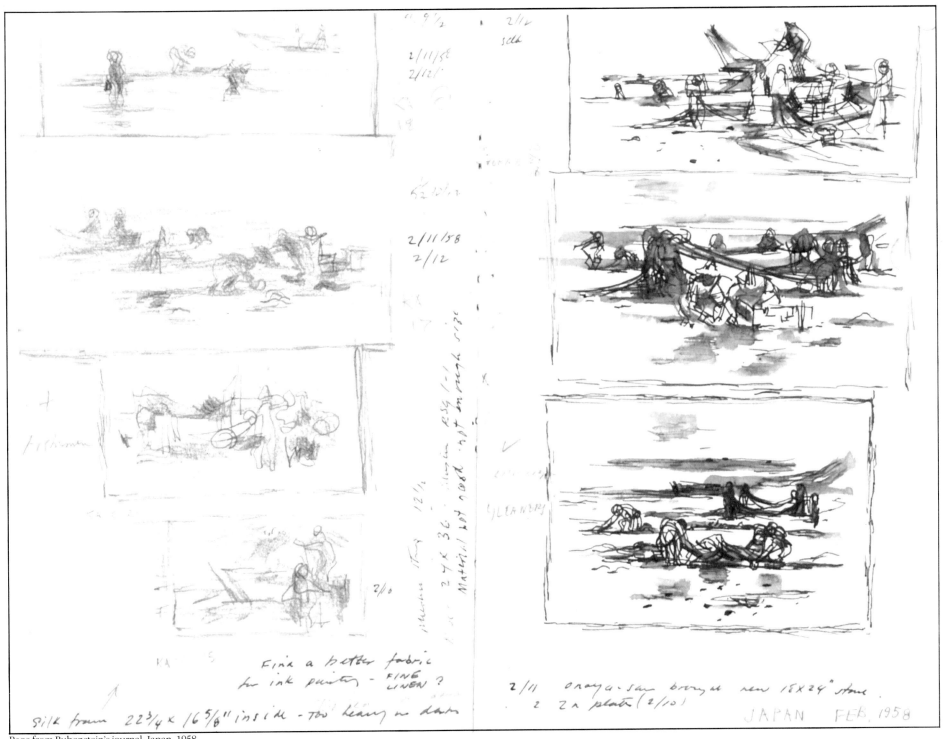

Page from Rubenstein's journal, Japan, 1958

Acknowledgments

Lewis Rubenstein has been painting the Hudson Valley's scenic vistas and Poughkeepsie's urban neighborhoods for over fifty years. It is indeed likely that anyone who has driven around the city and its environs during the past half century observed him, at one time or another, seated by the side of the road, surrounded by all the materials of his craft. This book represents the devotion of numerous individuals, all of whom share a profound admiration for the artist and his work. I would like to thank Rubenstein's colleagues, friends and family, whose substantial contributions of time and money helped make this book possible. In addition, I want to thank the Richard A. Florsheim Art Fund as well as the Lucy Maynard Salmon Fund of Vassar College for generous publication grants. I am grateful to Stephen and Julia Dunwell for providing computer assistance and to David Page for his advice on matters of publication and printing. Many thanks go to those individuals who allowed their paintings and drawings to be included in this book; and to Mike Djirdjirian who photographed nearly every work which appears in it. Nicolai Cikovsky, Jr., Douglas Dreishpoon, Rebecca E. Lawton and Ruth L. Middleton, all deserve special recognition for their contributions to the text. This book has been greatly enhanced by our designer, Abigail Sturges, whose extraordinary effort and sensitivity now provide a continual opportunity to enjoy Rubenstein's work in print. Finally I express my deep appreciation to the artist and his wife, Erica, for graciously providing valuable assistance throughout the entire project.

C.S.K.